WE FACE *FORWARD*
ART FROM
WEST AFRICA
TODAY

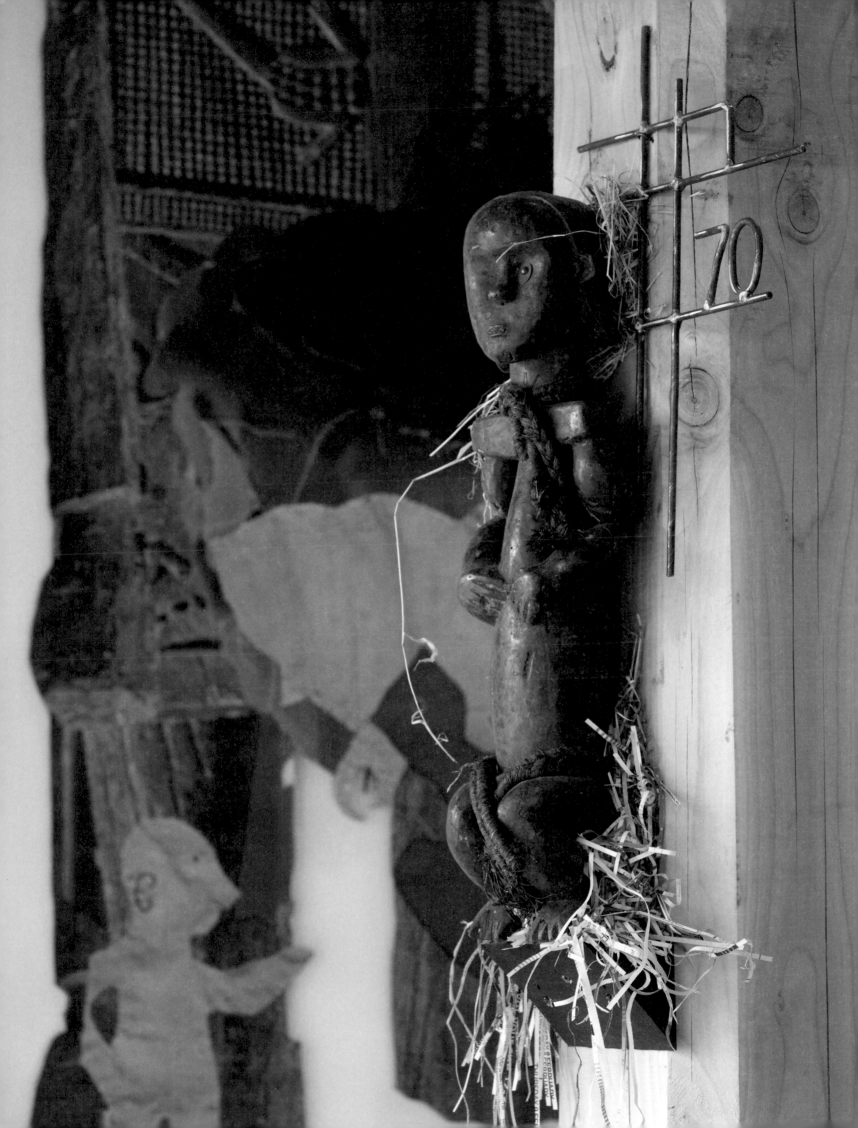

WE FACE *FORWARD*
ART FROM WEST AFRICA TODAY

Contents

Pascale Marthine Tayou
*The World Falls Apart (Le monde
s'effondre)* 2012 (detail)
Mixed media installation
Commissioned by Whitworth Art Gallery,
The University of Manchester
Photograph by Michael Pollard
Courtesy the artist and Galleria Continua,
San Gimignano / Beijing / Le Moulin

Foreword and Thanks

This is a project that has been grown through conversations and generosity, journeys and exchange. We have been made welcome in Senegal and Mali and also London, Llandudno, Paris and Helsinki and have found great support from Lagos, Nigeria and Douala, Cameroon. We hope this is the beginning of an ongoing conversation with an international African cultural sphere and we offer great gratitude and respect to everyone who has helped us shape this project.

Thanks to all the artists, designers and musicians who have responded to the project with such enthusiasm and energy.

Thanks to all our colleagues and partners from Manchester Art Gallery, Whitworth Art Gallery, Gallery of Costume, Manchester Museum, Band on the Wall who have embraced partnership working with creativity and passion, especially Mike Chadwick, Clare Gannaway, Emilie Janvrin, Miles Lambert, Nick Merriman and Gavin Sharp.

For their sterling support in many and various ways, thanks to: Martin Barlow, Lisa Beauchamp, Jack Bell, Yemisi Brown, Melissa Bugarella, Pierre Brullé, Bill Campbell and Maurice Carlin at Islington Mill, I&G Cohen Ltd, Margaree Cotton, Creative Concern, Creative Hands, Harry Crofton and Stephen O'Malley at Stockley, Ed Cross, Julie Deffrenne, Robert Devereux, Christine Eyene, Scott Fitzgerald, Ziggi Golding, Kerryn Greenberg, Sarah Hickson, Lubaina Himid, Baba Israel and the staff at Contact Theatre, Tessa Jackson and the staff at Iniva, Stephan Köhler, Koyo Kouoh and Marie-Hélène Pereira and the staff at Raw Material Company, Elisabeth Lalouschek and the staff at October Gallery, Roger Malbert, Elvira Dyangani Ose, Sarah Philp and the Jonathan Ruffer Curatorial Grant Programme, Michael Pollard, Ellie Pollock, Hannah Pool, Pascale Revert and Perimeter Art and Design, Ruth Mackenzie, Lucy Ramsden and the staff at the Manchester Conference Centre, Nick Reed and the staff at the Bridgewater Hall, Alan Rice, Nephertiti Schandorf, Laura Serani, Samuel Sidibé, Faye Scott-Farrington, Katrina Schwartz and the British Council, Bisi Silver, Toby Smith and the staff at Royal Northern College of Music, Francesca Spanò and Galeria Continua, Ruth Spencer, Alexander Taber Smith, Lucie Touya at the Institut Français, Eckhard Thiemann, Jack Thompson at Manchester International Festival, Nick Todd at DBN, Sokona Tounkara, Jari-Pekka Vanhala, Maria Varvana, Alan Ward, Cathy Wills, Stephanie Wyatt and the team at The Printworks.

Facing Forward: West Africa to Manchester
Maria Balshaw with Bryony Bond, Mary Griffiths, Natasha Howes

I am finishing this essay sitting on the roof terrace of the Djoloff Hotel in Dakar, in a brief moment of downtime in the relentless whirl of cultural activity that is Dak'Art, the art biennale that has thrived in Dakar since 1992. It is a global event that has spawned an OFF festival that, like Edinburgh, dwarfs its progenitor and stands as testament to the dynamism of independent art spaces and artists who find context in Dakar's long held commitment to the visual arts.

Youssou N'Dour, the recently created Minister for Culture in Senegal, has been in constant attendance at exhibition openings. It is difficult to decide what is more unusual – an internationally acclaimed pop musician becoming culture minister, or a culture minister who seems to genuinely believe in and take delight in contemporary art. It is tremendously exciting to be here, we are connecting with artists and colleagues who have helped us create this project. Manchester to Dakar does not, any more, feel like a long journey or an unlikely partnership.

This project began with music as well as visual art, so it feels all the more fitting that Senegal's most famous, and most globally connected, musician is the cultural host for the biennale. The germ of the idea that has evolved emerged whilst listening to Malian musician Toumani Diabaté. Diabaté, recognized as one of the great virtuosos of the kora, exemplifies the sophisticated negotiation between history and a contemporary, globalised refashioning of that tradition – a remaking that gives creative strength and subtle political challenge.[1]

The track that was my particular inspiration is called *Cantelowes* from *The Mandé Variations* album. It contains a playful quotation from *The Good, the Bad and the Ugly*, picked out on the kora. The riff is woven into the flowing, multi-layered texture of the music. This appropriation of an Italian director and composer's rendition of the American West, filmed most often in Spain[2], offers a powerful example of the circulation of black Atlantic culture that Paul Gilroy describes in his seminal analysis of black art, history and contemporary cultural production.[3] In the layering of sound in this music I felt resonance with the woven textiles, from Mali, Nigeria, Senegal and Ghana, that make such an important contribution to the world textiles collection at the Whitworth. Held here because of Manchester's global textiles trade and the cycles of trade, design influence, collecting and exchange, that marks black Atlantic exchange and the globalized circulation of cultural objects long before the 21st century. As Christine Eyene points out, in her essay in this volume, textiles offer a rich metaphor for understanding the power dynamics of cultural exchange, without presuming to be a prescriptive frame:

> If Cottonopolis thrived on its cotton manufacturers and the textile industry, then thread and fabric appear as interesting metaphors to explore a transcontinental space transposed from the historical or factual, to the realm of visual subjectivity and abstracted signs. [page 22]

1. Diabaté explained to a Manchester audience recently that he came from a family with a 700 year long tradition of kora playing.

2. Known best as spaghetti westerns, referencing the Italian production and direction of these nevertheless quintessentially American movies, they are also sometimes nicknamed paella Westerns in reference to their film locations, which were most usually in Murcia and the Apuljarras.

3. Paul Gilroy, The Black Atlantic: Modernity and Double Consciousness (Cambridge Massachusetts: Harvard University Press, 1993).

While Manchester's collections are rich with the history of art and craft from West Africa – the legacy of colonialism – we knew almost nothing about the contemporary cultural scene across the Anglophone and Francophone countries of West Africa.[4] *We Face Forward: Art from West Africa Today* was born out of a desire to remedy this. It has proved to be a project as rich, subtle and multivalent as the delicate fragment of the American west lifted by a Malian master, courtesy of an Italian. The project has been developed with a desire to know the 'now' but with a ready awareness of the colonial legacy that has shaped Manchester's collections. As Eyene comments, '*We Face Forward*, the title of this exhibition says, but not without awareness of a certain cultural heritage'. It is this that has confined our selection to artists from West Africa.[5]

There were other pushes and pulls that have brought this project into being. A grant from the Paul Hamlyn Foundation's Breakthrough Fund, charged me with developing work at the Whitworth and Manchester Art Gallery that would move the organisations to a new level in terms of the scope of ambition for our programme, our collections, our audiences and the artists we work with. In particular, I wanted us to expand the international dimensions of our work, in ways that would resonate with our existing collections and the many people from all over the world who are now Mancunians. The final impetus was an invitation to make something extraordinary happen in Manchester – a new global dialogue – in the year when so many people from all over the world would be coming to Manchester and the UK for the Olympics. Our thinking was inspired by a desire to take seriously some of the key humanitarian themes of the Olympic movement – promoting understanding between cultures and fostering social justice – and *We Face Forward* has looked to artists from West Africa to bring these issues to our attention.

Our most pressing wish was to explore the incredibly diverse and dynamic art being made by artists from West African countries, not as an exhibition of work that is 'separate' from the global art scene, or defined through ethnographic or geographic containment, but as a body of work that is actively engaged in shaping and challenging how that world is configured. This is art which demonstrates what Koyo Kouoh describes in this catalogue as, 'the contagious dynamism of African cultural producers.' [page 28]

We wanted to do a project that would take over all of Manchester by stepping beyond the institutions of the gallery and museum to embrace music, food, performance, hands on activity – connecting to and engaging all Mancunians, especially those of West African descent, despite, as Christine Eyene observes, the harsh fact of that relationship beginning with the slave trade:

> Against this background, it can only make sense that cultural offerings from public art institutions would reflect the diversity of their own population. [page 22]

We Face Forward has built relationships with parts of the world that Manchester traded with in the 19th and 20th centuries, to reconfigure that relationship as one of mutual learning, respect and dialogue that will have a long term impact on the city's collections, its galleries and its museums. Working with

4. See David Morris et al, *Trade and Empire: Remembering Slavery* (Manchester, UK: Whitworth Art Gallery and University of Central Lancashire, 2011), for a series of essays that explore the legacy of slavery in the shaping of Manchester's museum collections.

5. There are sixteen countries alone in the Economic Community of West African states, *We Face Forward* also includes artists from Cameroon, a country officially in Central Africa, but one whose artistic output and shared history meant its inclusion was only appropriate.

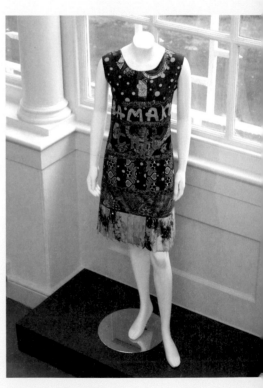

Duro Olowu
Bamako Chic Autumn / Winter 2007
Multi print silk lame and cotton dress
Installation at Gallery of Costume, Platt Hall
Photograph by Michael Pollard
Image courtesy the designer

partners like Koyo Kouoh's Raw Material Company and Kër Thiossane in Dakar, Bisi Silva's Centre for Contemporary Art, Lagos, Marilyn Douala-Bell and Didier Schaub's doual'art in Cameroon we connect to what Kouoh recognizes as an independent, critical, private cultural sector which offers, 'brave models for how to fill in the institutional void.' [page 27]

More prosaically, but of equal importance, we have made new friends and colleagues, travelled beyond our own comfortable territories and are relishing the contagious impact of the artists and institutions we are collaborating with. We firmly believe that this exhibition is only the beginning of a process that will continue to shape our practice and our collections, in ways that are more appropriate, more diverse and more politically engaged with our 21st century context and the globalised, if still unequal, context of the contemporary art world.

We Face Forward also marks a new era in Manchester's two major galleries. It is the first occasion in their shared 123 year history that the two galleries have ever worked as a single entity to curate a major exhibition together. Between these institutions, and with 33 visual artists, more than 40 musicians, and a team of national and international advisors, collaboration has been the method and the ambition for this season of West African art and music in Manchester.

Cultural Circulation – the Black Atlantic

Unsurprisingly for galleries based in Manchester, the Whitworth and Manchester City Galleries hold nationally significant collections of textiles and costume. The textiles collection at the Whitworth was initially established as a resource to inspire the textile industry in the North West, giving access to the best in design and techniques from across the world. As a result the collection is overwhelmingly international and the countries from which the collection is drawn plot Manchester's historical and economic international relations. Over 20 per cent of the collection comes from Africa, with a significant portion of this coming from countries in West Africa.

By the time Manchester was a force on the global scene in the early nineteeth century, its relations with West Africa were already complex and wide-ranging. Cotton was one of the key products in the trans-Atlantic slave trade. Manchester-made cloths were traded in West Africa for slaves, who were in turn transported to the Caribbean, and to the Americas where they worked on cotton plantations, picking the cotton that was sent to Manchester to be processed and begin the cycle again.

Towards the end of the 19th century, Manchester manufacturers and merchants like James Hutton were advocating British colonial intervention in West Africa to protect 'legitimate' trade. Pressures from commercial lobbyists, and the competition for raw materials from other European countries, helped precipitate the scramble for Africa and by 1914 the entire continent (except Ethiopia and Liberia) was under the colonial rule of European powers.

Meschac Gaba's work *Ensemble*, which acts as the emblem and identity of *We Face Forward*, is a starburst of all the West African flags together with the

'6 Bougies', cloth for the West African Market, 1940s England (Manchester)
Cotton printed in industrial wax batik technique
Courtesy Whitworth Art Gallery, The University of Manchester

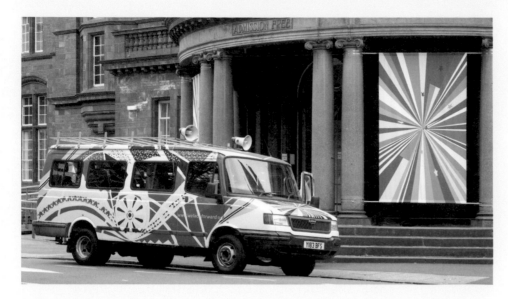

Entrance to Whitworth Art Gallery,
We Face Forward Art Bus and
Meschac Gaba's *Ensemble* 2012
Photograph by Michael Pollard

Union Jack. Emanating from, or converging into, a central point, Gaba's work simultaneously demonstrates the diversity of nations that makes up the region of West Africa alone, and the absurdity and need to disregard political boundaries, if we are ever to move beyond this colonial legacy. The roulette wheel structure of his organisation of the flags serves to emphasise the arbitrary designations of national identities.

Manchester's connections with Africa are not solely captured by analysis of the exploitation of the colonial era, as Alan Rice's essay in this volume makes clear. There was widely felt solidarity and support for freedom for Africans within the North West's trade union movement. In 1945 the fifth Pan-African Congress was held in Manchester. Selected in part because of the city's level of political consciousness, the Congress was also the first to include people from the African Diaspora; not just Africans, but African-Caribbeans and African-Americans. Future African leaders such as Jomo Kenyatta and Kwame Nkrumah attended the six day conference, at which decisions taken, as the plaque hanging outside what is now the Manchester School of Art states, 'led to the liberation of African countries.' The conference received little coverage in the British press at the time, but it was a significant step in the journey towards the end of colonial rule.

The title, *We Face Forward*, comes from a speech made by Nkrumah in 1960.[6] About to be elected as the first president of a newly independent Ghana, Nkrumah said 'We face neither East nor West; we face forward.' Emphasising his resistance to the competing cold war powers, his spirit of independence has informed the conception of this exhibition and season. *We Face Forward* seeks to acknowledge the past and the global interrelations and connections throughout the world, but embodies a sense of independent expression.

Pascale Marthine Tayou has said, 'My African origins are of course a fact of birth: there is no GPS where I am from, but my gaze fans out from my continent along the routes of the world.'[7] Describing himself as a stone which does gather moss, Tayou picks up a little from wherever he travels. Wishing to articulate a sense of his own place in relation to the past and to his geography, his works flit back and forth between conceptions of Africa, Europe, Asia, the universal; each sculpture, found object, whether precious gemstone or discarded rubbish,

Pascale Martine Tayou
Poupée Pascale 2010 – 2012
Crystal, mixed media
Installation at Manchester Art Gallery
Photograph by Michael Pollard
Courtesy the artist and Galleria Continua,
San Gimignano / Beijing / Le Moulin

6. Kwame Nkrumah in a speech given on
7 April 1960 to welcome in Accra, Ghana
delegates to a conference on 'Positive
Action and Security in Africa' as quoted in
Kwame Nkrumah, *I Speak of Freedom:
A Statement of African Ideology* (London:
Heinemann, 1961) p. 219.

7. Nicholas Bourriaud, *Altermodern: Tate
Triennial* (London: Tate Publishing, 2009)
p. 206.

Barthélémy Toguo
Redemption 2012 (detail)

Mixed media
Commissioned by Manchester Art Gallery
Photograph by Michael Pollard
Courtesy the artist, Bandjoun Station,
Cameroon and Galerie Lelong, Paris

8. At the time of writing two participants,
Amadau Sanago and Marie Hélène Pereira
have had their visa applications to attend
the exhibition opening refused.

9. See exhibition leaflet by Jennifer Harris,
for *Cotton: Global Threads*, Whitworth Art
Gallery, 10 Feb – 15 May, 2012.

colliding and combining with the other. In the Whitworth, his installation fills our largest gallery and reaches out into the park, connecting to communities of West African descent in the city and also resonating with the textiles in the collection that both represented West Africa but also exerted their influence on the Manchester textiles industry.

For Barthélémy Toguo too, travel is an important activity. Installations of photographs and sculptures have documented Toguo's passage along the trade routes of Cameroon's exports. Carrying outlandish wooden carvings of suitcases or outsized wooden hats, Toguo mimics the journeys of African material goods, without the visa necessary for a human cargo. Free mobility and borderless states is a still a condition for the privileged few.[8]

Here in Manchester, the ABC textile company, the pre-eminent makers of 'African' wax-resist cloth, has been sending and receiving cloth along just such routes, since the 1880s. The cloth is most characteristically recognized as Nigerian, but is actually a global commodity par-exellence, coming from Java (now Indonesia), through Holland, to West Africa and then to Manchester.[9] Togou's articulation of the complexity of travel, trade and power underscores an important theme for this project; that far from representing a discrete 'West African' aesthetic, artists from West Africa are part of a global dialogue about art, culture, aesthetics and power and, moreover, these global connections go back hundreds of years.

Continuing this exploration the new commission by Victoria Udondian, approaches the textile collections as a research library and threads a different story about the back and forth of the textile trade, identity and history.

Tradition and the Contemporary World

The paradoxes and benefits of tradition and modernity are explored in work by many of the artists in *We Face Forward*. Rather as the great musician-griots of traditional instruments like the kora and balafon have forged new contemporary forms by taking from and contributing to the development of Euro-American popular music, visual artists engage with but also critique European visual culture. Artists make use of traditional forms to address contemporary issues, use modern methods to represent aspects of life that are shaped by custom and offer significant challenges both to the visual stereotypes that so often shape Northern perceptions of life in Africa, and to the European separation of craft object from fine art practice, the ancient and the contemporary, the valued and the thrown away.

El Anatsui's astonishing works of woven liquor bottle tops and foil wrappings resonate with histories of early European and African trade. Textiles and liquor were some of the staple goods traded for slaves across West Africa. Even today's local brands of gin and brandy used by Anatsui reference military interventions or political slogans in their names. Anatsui transforms these raw materials into stunning cascades of colour and beauty, but the histories contained within his raw material threads through each work.

Through an intense understanding of the traditions of cotton spinning, weaving and indigo dying, Aboubakar Fofana makes traditional lengths of cloth and also contemporary works of art that reflect upon labour and culture in Mali. His practice is both the making of the work and the teaching and encouraging of others in the city and the villages to re-learn the old methods of production for growing, hand spinning and weaving cotton and indigo. Contemporary and minimal, his cloth is highly valued in the European and American market, but its purpose is also to retain the viability of the Malian tradition in the now – as an ethical, sustainable cultural practice.

One of the most powerful ways in which the synchronic modes of traditional and modern are brought together is through the medium of photography. Whilst the history of African's self-representation in photography goes back to the mid 19th century, it was in the 1950s that Africans much more actively seized a position of power as the photographer rather than the photographed.[10] In Mali, this action found fruition in a mid 20th century explosion of studio portraiture and a re-envisioning of the European style of presenting the sitter, this time with a West African inflection. The exceptional bodies of work of Malick Sidibé, Abderramane Sakaly, Soungalo Malé and Hamidou Maiga show Malians as they have chosen to be portrayed – in their best clothes, with prized possessions, at important moments of their lives. These are aspirational portraits, constructing identity and (re)framing the self, through the lens of the camera.

Hélène Amazou, on the contrary, turns the camera upon her own body, picturing herself nearly not there, apparition-like, in a dilapidated European room. Dissolving the portrait, she makes a strong political point about the erasure of the black citizen that European immigration laws continue to enact. Her photographs evoke the isolation and insecurity she experienced whilst seeking asylum in Belgium – a body without a home, for more than two years. Making a deliberate reference to the photographs of Francesca Woodman, the analogy between the gendered and racial invisibility serves not as direct comparison so much as the marking of the imposition of a unwanted political rubbing out of the black citizen that continues into the 21st Century.

The documentary tradition has also been assimilated and reinvigorated by West Africans. Nyaba Léon Ouedraogo, Nyani Quarmyne and George Osodi all investigate the circumstances of people's lives in Ghana, Nigeria and beyond. Their photographs often confront the political and economic pressures on the poor and the role Western companies play in producing these conditions. Whilst Western documentary photographers have made, and continue to make, work in Africa, it is immensely important that Africans tell their own stories according to their own visual idioms. Resisting the clichéd view of the destitution or desolation of Africa (what Koyo Kouoh calls the photojournalistic shorthand) the photographs shown here in Manchester very often evoke beauty and aesthetic pleasure as the first response, with a political aftershock that asks for further engagement from the viewer with the actuality of people's daily lives.

Nii Obodai's approach to storytelling differs from the documentary style. Concerned with seeking out the soul of Ghana, he travels the country making poetic images that capture glimpses of what he sees as the truth of place and

10. Erin Haney, *Exposures, Photography and Africa*, (London: Reaktion Books 2010).

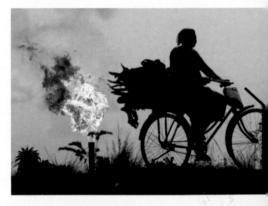

George Osodi
Oil Rich Niger Delta 2003–2007
Photograph
Courtesy the artist and Z Photographic Ltd

Nii Obodai
1966 2009
Digital print
Courtesy the artist and Institut Français

person. Working with a Leica camera and an expert understanding of the affect of light and shade on black and white film, Obodai captures fleeting shadows, an animal trotting by, a village street white with the heat of the sun, a man's head dematerialising within a burst of light, a girl merging into the beach she plays on. Similarly, Mohamed Camara uses the lens of a video camera to watch the doorway of an African house. With patience and skill, he brings us some way to understanding the never-closed nature of the curtained door, the hot light without, and the cool gloom within.

Amadou Sanogo's paintings are made in such a house in Bamako, Mali, and are shaped by the circumstances of that building – he buys the un-stretched canvases in the local market, and the size of the paintings relate to the large concrete slab outside his door. He refuses the wooden stretcher, as an unnecessary European imposition on the body of his work. A critique of international and national politics, the imagery in his paintings is drawn from news stories that the artist watches avidly on TV5 Monde. Politicians of all forms, corrupt journalists and judiciary all fall under the astute eye of Sanogo. His is a specifically Bamako intervention in both global political debates and the regulation forms of the contemporary art market. A similar point is articulated in Barthélémy Togou's extraordinary watercolours. Offering, as they have done through the centuries, a rapid way of capturing reality, Toguo's paintings sits alongside his large scale installations as a running commentary on the venality of global politics, the impact of Western commerce on West Africa and the loss of traditional values and cultural practices.

The Impact of the North on the South

Environmental sustainability is a central concern for artists from all over West Africa, from Senegal to Ghana, Burkina Faso to Nigeria. Whether it is climate change, unreliable power supplies, the effect of oil extraction, the commercial exploitation of waste materials or the results of dramatic urbanisation, artists are making work which draws attention to the unsettling immediacy of these environmental challenges. The work acts as an agent for change and demands that viewers take notice of the profound and long term implications for the global environment.

Power cuts are a huge problem in Dakar, Senegal. Piniang's paintings depict the built-up suburbs plunged into darkness, with fragments of collaged newspaper text alluding to the electricity crisis and the noise of the overcrowded accommodation, like snippets of overheard conversation. Abdoulaye Armin Kane goes further in his animation *The Event (L'événement)* which illustrates a traffic accident directly caused by a powercut. Kane advocates a shared sense of responsibility; the liability of the electricity companies to prevent the power cuts and for individuals to act responsibly when a power cut occurs.

A compelling example of the contested issue of energy concerns the oil of Nigeria. 'Black gold' is Nigeria's largest export and accounts for 95 per cent of their exports. George Osodi's celebrated *Oil Rich Niger Delta* photographic

essay, a series of 200 images taken between 2003 and 2007, starkly shows the profound and detrimental impact oil extraction has on the lives, health and freedoms of the people who live in the ravished landscape of this densely populated region. Whilst the images are striking in composition and aesthetic sensibility, they also reveal the exploitation of the local population who do not benefit from the wealth generated for the multinational companies. Romuald Hazoumè's film *La Roulette Béninoise* focuses on the illegal trade of Nigerian oil in Benin. Petrol traffickers ferry contraband petrol to towns and villages on motorbikes overladen with expanded black jerry cans which are at constant risk of explosion. Both these artists' work suggests that rather than liberating people, the extraction and trading of oil can result in the exploitation of human labour, a form of contemporary enslavement.

Another artist showing the dramatic effect that environmental damage has on the lives of ordinary people is photographer Nyani Quarmyne. His series *We Were Once 3 Miles from the Sea* documents the encroaching sea and coastal erosion which has left the inland fishing village of Totope, near Ada, Ghana on the water's edge with many homes buried by the rising sand.

Waste products discarded by those in the Northern hemisphere are an issue which is addressed by a number of artists. Romuald Hazoumè's use of discarded Western products to create a street trader's stall in *ARTicle 14*, references the historic trade routes between Europe and West Africa. It demonstrates how items which have become defunct, outdated and unfashionable to Western tastes still have a commercial value to the trader. Nyaba Léon Ouedraogo documented the Aglobloshie Dump in Accra, Ghana, where electronic waste is shipped from Europe and North America. *The Hell of Copper* series depicts young Ghanians who dismantle old computers and burn the plastic or rubber components to reveal the precious copper which is then resold. There are no masks or gloves and the lead, mercury, cadmium and PVC plastic are incredibly toxic to the human body. These chemicals have seeped into the nearby canal and also contaminate the grazing land for cows and sheep. In a different vein, but again utilising the leftover detritus of Western commercialisation, Lucy Azubuike's abstract collages are pieced together from the remains of advertising posters that are plastered across Lagos, extolling the delights of mobile phones and soft drinks, rendered quickly indecipherable by the intense Lagos heat and humidity.

Urbanisation in Nigeria has made Lagos into a mega metropolis with a population estimated anywhere between ten and seventeen million. Lagos is a city which is never quiet; there is the constant hum of generators, the calls of street hawkers, the horns and engines of cars, motorbikes, trucks and taxis on the jam packed roads, the melodies of Yoruba songs, imported hip-hop and political Afrobeat on the radio all jostling for space in the richly textured urban soundscape. Emeke Ogboh is passionate about these sounds which he records, archives and presents in other locations, producing in the listener a profound sense of dislocation. Apart from noise pollution, another effect of such a large population is the challenge of effective waste management. Charles Okereke's series *The Canal People* consists of seductive images of rubbish floating on the

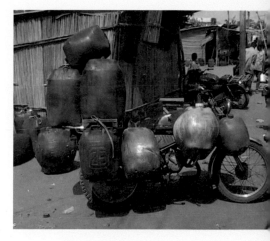

Romuald Hazoumè
La Roulette Béninoise 2004
(still)
Image courtesy the artist and October Gallery, London

Charles Okereke
From *The Canal People* series
2009–2010:

Ahoy
Photograph
Image courtesy the artist

canal in Lagos. Discarded drinks cans, orange peel, plastic cartons and effluent are presented with a poetic beauty which belies the darker message about pollution for those who live alongside human debris. These artists' responses to the increasing environmental crisis focus above all on the human cost and make a compelling argument for an urgent global response to these issues if there is to be sustainability in the Northern hemisphere and the global South.

Which way next? This the question to be explored as a consequence of this project – an issue that will be debated with interested parties close to home, like artist Lubaina Himid and academic Alan Rice, whose contributions to the shaping of this exhibition go far beyond their essays that are part of this catalogue, and with our connected network of cultural activists and artists across West Africa, when we gather for a closing symposium in September. Some next steps are already in place. Works by many of the artists in the exhibition will take their place in the collections of the Whitworth and Manchester Art Gallery. Nyaba Léon Ouedraogo is currently making a series of photographs in the Congo, which chime with Manchester Museum's campaigning mission in relation to environmental sustainability; so these will appear in the city next year. For now though, we will let the art and the music do its work, infecting Manchester with a different cultural flavour – looking forward but always aware of our past.

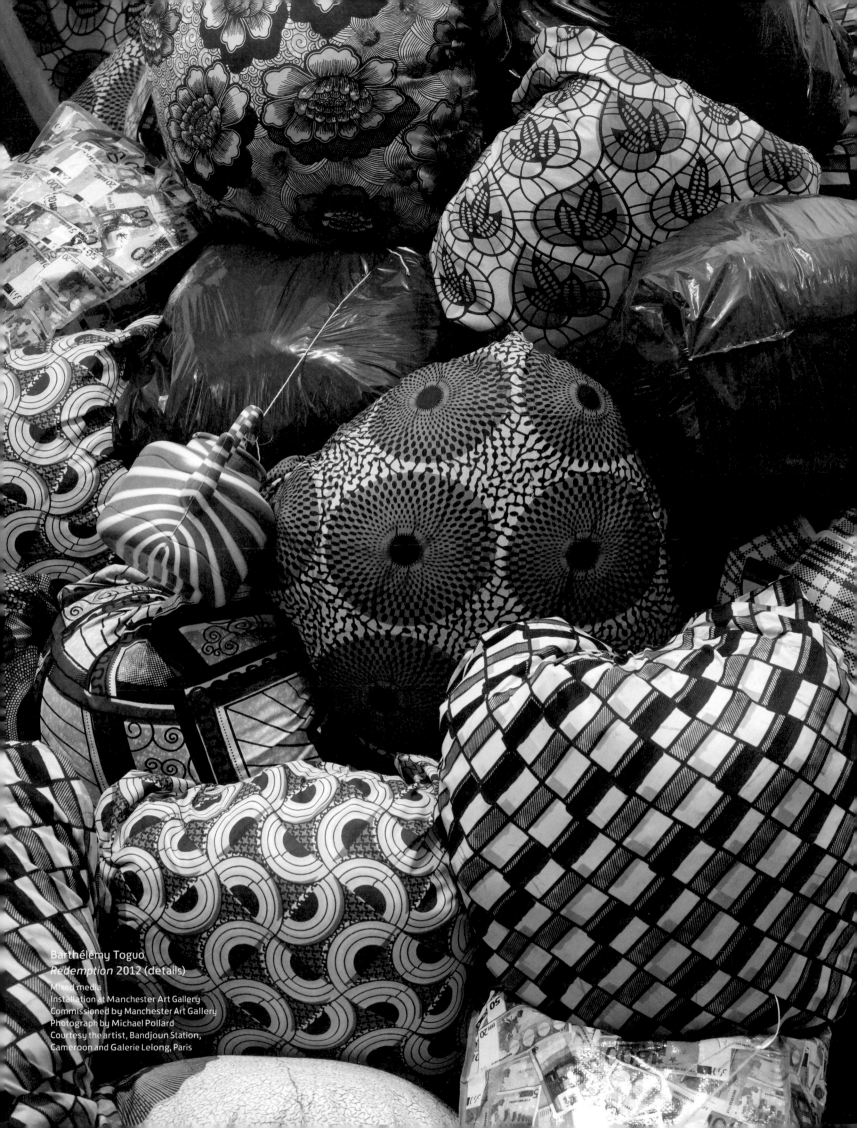

Barthélemy Toguo
Redemption 2012 (details)
Mixed media
Installation at Manchester Art Gallery
Commissioned by Manchester Art Gallery
Photograph by Michael Pollard
Courtesy the artist, Bandjoun Station,
Cameroon and Galerie Lelong, Paris

Tracing Roots and Routes and Facing Forward:
African Atlantic Residents and Sojourners Make their Mark in the
Cottonopolis 1789-1949
Alan Rice

On 20th July 1790 the *Manchester Mercury and Harrop General Advertiser* ran an advertisement for 'the second and corrected edition' of the *Interesting Narrative of the Life of Olaudah Equiano, or Gustavus Vassa, the African Written by Himself.* Olaudah Equiano (c.1745-97) on probably the first book tour by a black author in Britain, told his potential new readers in England's second-most populous city:

> From the Reception this Work has met with from above Seven Hundred Persons of all Denominations – the Author humbly Thanks his numerous Friends for past Favours; and as a new Edition is now out, he most respectfully solicits the Favour and Encouragement of the candid and unprejudiced Friends of the Africans.[1]

Equiano, was at the height of his fame when he visited Manchester and the visit made a great impression on radical thinkers in the town. We can see this by the 1790 letter from Thomas Walker, one of many testimonials that frames the ninth enlarged edition of Equiano's famous text published in 1794, and which recommends the book to his fellow Mancunians. Equiano's tactic of selling his book through the promotion of himself and his African lineage was very successful and the book's anti-slavery message helped to galvanise abolitionist sentiment nationally. The warm reception given to him in Manchester, a radical centre responsible for landmark petitions against the slave trade in 1787 (10,000 signatures) and 1806-7 (2,400 gathered in much less time) established a welcoming pattern which African diasporan visitors were to find repeated over the next 160 years.

Probably the next celebrated black figure to make his mark on the city was the American-born Shakespearean actor, Ira Aldridge (1807-67), otherwise known as the 'African Roscius', who had arrived in Liverpool just three years before seeking his fortune on the stage in a less racist environment than he encountered in the United States. Unfortunately, his performances in London attracted racist reviews about his inability to pronounce words properly because of his 'negro lips'. He was better welcomed in the provinces and appeared at the Theatre Royal in Manchester in February 1827. He often returned to Manchester and was especially famous, as the *Manchester Courier* noted in its review, for the novelty on the English stage of he, *'An Actor of Colour'*, playing Shakespeare's *Othello.* His Manchester appearance as the Moor was recorded for posterity by the artist James Northcote whose *Head of a Negro in the Character of Othello* was exhibited at the Royal Manchester Institute later in 1827. Aldridge was to have a distinguished career, playing non-black roles as well as his signature black leads in locations in Britain and Europe. He became a British citizen in 1863, before dying prematurely whilst touring Poland in Łódź in 1867.[2] The Northcote portrait absorbed into the permanent collection of the Manchester Art Gallery in 1882 is proof positive of the mark he left on the city.[3]

1. Vincent Carretta, *Equiano, the African: Biography of a Self-Made Man* (London: Penguin, 2006), p. 337.

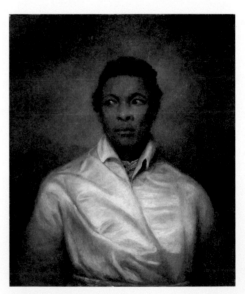

James Northcote
Othello, the Moor of Venice 1826
Oil on canvas
Image courtesy Manchester Art Gallery

2. David Dabydeen, John Gilmore and Cecily Jones, *Oxford Companion to Black British History* (Oxford: Oxford University Press, 2007), pp. 23–25.

3. Jan Marsh, *Black Victorians: Black People in British Art 1800-1900* (Aldershot: Lunn Humphries, 2005) p. 155.

4. John M. Turner, 'Pablo Fanque, Black Circus Proprietor' in Gretchen Holbrook Gerzina (ed.) *Black Victorians, Black Victoriana* (New Brunswick, NJ: Rutgers University Press) p. 22.

5. ibid., p. 21.

6. ibid., p. 21.

It was not only in the political, literary, artistic and theatrical worlds that Africans made their mark on the city. In popular culture too, there was a significant black presence in the early 19th century. The equestrian circus performer and proprietor Pablo Fanque (1796-1871) was born William Darby in Norwich, the son of an African-born butler, but his interest in the circus took him far from his East Anglian roots. He was a master at equestrian tricks, rope walking, mighty leaps and rope vaulting. His circus became famous across the North from the 1830s through to the end of the 1860s before his death in Stockport in 1871. His colourful career took him all over the country, but his favourite environs were in the small towns of Lancashire where 'by his own industry and talent he got together as fine a stud of horses and ponies as any in England'.[4] He was 'the loftiest jumper in England ... leaping over a post chaise placed lengthwise with a pair of horses in the shafts and through a military drum at the same time'.[5] His circus played numerous venues but had prestigious shows at the Manchester Free Trade Hall (1851-2) and the Manchester Philharmonic (1855). In the 1860s he annually erected his circus for the fair.

> Pablo's circus used to stand at the Knott Mill Fair Ground at the side near the station, each Easter. Pablo's occupied half that side of the ground, the other half being taken up with Wombwell's Beast Show.

Other circuses and menageries came to the city including Hilton's Menagerie whose West Indian born lion tamer Makomo (a.k.a. Arthur Williams) was reported in the Manchester procession 'dressed as a wild man in skin and feathers'. Obviously, more in control of his performance on his return 'he had discarded his skin and feathers and appeared in a very good black suit'.[6]

The dangers of being asked to play the minstrel were obvious in the mid-19th century when imperial racialist ideas infected popular cultural forms like the musical theatre and circus culture. It is a testament to Fanque and Williams that they resisted or manipulated racial stereotypes in their favour to create enormously successful careers. Fanque's fame is assured by the backstory to the lyrics of the John Lennon written, Beatles song 'For the Benefit of Mr Kite' from *Sgt. Pepper's Lonely Hearts Club Band* which was based on an antique circus poster which highlighted his famed circus. Lennon is photographed pointing at the poster, illustrating a carnivalesque sepia-tinged Ye Olde England. For him the name Pablo Fanque is a mere exoticism, but from our perspective he complicates such Anglocentric and nostalgic readings of British and Northern history, illustrating a black presence right at the heart of vernacular culture in the nation and the region.

The mid-19th century also saw the arrival in Manchester of a number of black American abolitionist activists, most famously Frederick Douglass who stayed at 22 St. Ann's Square in 1846 and wrote his famous letter justifying his decision to pay his master Thomas Auld to buy his freedom, using money he had collected from supporters in Britain. His brilliant rhetoric, emboldened by his liberating sojourn in Britain amidst 'Monarchical Freedom' contrasted to the 'Republican

Slavery' still extant in his homeland, lambasts the hypocrisy of the American government:

> I will hold up those papers before the world, in proof of the plundering character of the American government. It shall be the brand of infamy, stamping the nation, in whose name the deed was done, as a great aggregation of hypocrites, thieves and liars – and their condemnation is just. They declare that all men are created equal, and have a natural and inalienable right to liberty, while they rob me of £163 15 shillings, as a condition of my enjoying this natural and inalienable right. It will be their condemnation, in their own hand-writing, and may be held up to the world as a means of humbling that haughty republic into repentance.[7]

Feeling a similar freedom on his arrival in 1850, Henry Box Brown like Douglass spoke at abolitionist meetings throughout the country. Box Brown, in a dramatic escape in 1849, had been transported in a crate by post from Richmond in the slave South to Philadelphia in the free North and he now retold this story in meetings all over Northern Britain. It was in Manchester that Brown made the contacts that enabled him to publish the second, definitive, edition of his book, *Narrative of the Life of Henry Box Brown,* in 1851, through the good offices of Thomas G. Lee, Minister of the New Windsor Chapel in Salford. The successful publication of this work in Salford attested to the widespread support for abolition in Manchester and the surrounding cotton towns. Brown, like many other abolitionist visitors, tapped into this nascent transatlantic radicalism. Brown, though was an abolitionist unlike the strait-laced, temperate norm. The scope of his maverick performative act which he performed often in Manchester can be shown by a recently discovered playbill for a Mr. Henry Box Brown event at the Music Hall in Shrewsbury. The bill promotes 'For Five Days Only' in December 1859 Brown's 'Grand Moving Mirror of Africa and America! Followed by the Diorama of the Holy Land!' Central to the former was his escape in the box which also provides the major visual image on the bill. By 1859, Brown's unconventional escape had become the visual signifier that framed his other performative activities. The text on the poster unselfconsciously promotes the aesthetic dimension of his life and work as a framework for his political agenda:

> The public … when they witness this entertainment, … will not only appreciate it as a work of art but also award it that approbation that all faithfully executed paintings should command.[8]

Casting political action as dramatic art, the bill also promises that

> 'Mr. H Box Brown will appear in his Dress as a Native Prince' in a performance highlighting the nobility of the African … before the advent of the transatlantic slave trade. 'APPROPRIATE MUSIC WILL BE IN ATTENDANCE' to provide a soundscape to the chronologies and geographies presented.

These details underline the importance of visual iconography and the performative in fully understanding not just Brown but the wider culture of

7. Frederick Douglass, Letter to Henry C. Wright, December 22nd 1846. Foner, Philip (ed). *Life and Writings of Frederick Douglass* (New York: International Publishers, 1950) Vol. I, p. 199.

8. Entertainments Bill, *Henry Box Brown showing a Mirror of Africa and America at the Music Hall*, 12-17 December 1859, 665/4/367, Shropshire Archives.

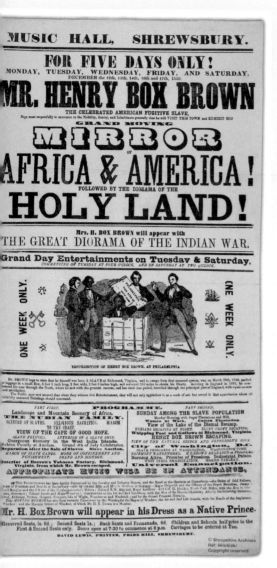

Entertainment Bill 1859
Henry Box Brown showing a Mirror of Africa
and America at the Music Hall
Image courtesy Shropshire Archives

9. Michael Herbert, *Never Counted Out! The
Story of Len Johnson Manchester's Black
Boxing Hero and Communist* (Manchester:
Dropped Aitches Press, 1992) p. 32.

10. ibid., p. 41.

abolition. Brown uses his black bodily presence as a weapon against slavery, but with an eye to entertainment value that establishes him as the showman par excellence. Playbills posted throughout a town or city invited the non-literate or those unable to access slave narratives into the exotic, counter-cultural world of African American abolitionism. They advertise the presence of radical black transatlantic figures, transmitting information about the institution of chattel slavery beyond the sphere of the chattering classes, making inroads into popular culture at the same time as helping to define the political arena.

Professor Henry Box Brown is recorded by the 1871 census as living at 87 Moreton Street, Cheetham, Manchester, with his Cornish wife Jane, two daughters and a son, and shows that he was by now doing well enough in his chosen profession of public lecturer to have a servant. His counter-cultural political showmanship provides a link between an often po-faced radical political culture and the world of entertainment highlighted by Pablo Fanque.

A similar combination of political activism and engagement with a more popular form is exemplified in the career of the black Mancunian Len Johnson (1902-74). Johnson was born and brought up in Manchester, the son of a West African sailor/engineer who was part of a growing black maritime population brought to Manchester in the wake of the Manchester Ship Canal which opened in 1894. Some settled, and, like Len's father William Benker Johnson, married white women forming a small but thriving black community. Len Johnson principally made his name as a boxer who fought throughout Britain, on Continental Europe and as far afield as Australia between 1921 and 1933, beating the best pugilists at his weight. By 1929, the *Sporting Chronicle* was lauding, 'Manchester's brilliant middleweight who has time and again proved his worth without obtaining an opportunity to box for the championship, which many believe he would wrench from Alex Ireland...'[9] Johnson was barred from fighting for the British championship by the racist rules of the British Board of Boxing Control who blatantly restricted their title fights held at the National Sporting Club in London to 'boxers of white parents'. On his first retirement in 1931 he bitterly summed up his situation: 'I think I am the only man in the world who is barred from a championship fight in his own country. I am willing to fight anyone ... but the colour prejudice is against me ... I am banned so I am getting out.'[10] Such a stellar sporting careers stymied by British racism would make Johnson an essential subject for our survey of the African diasporan presence in Manchester, however, his second career in politics allows us to tell some later and compelling narratives that bring Manchester to the centre of the Pan-African struggle for human rights in the wake of the end of the Second World War.

Johnson was a local delegate to the Pan-African Congress which met in the Chorlton-on-Medlock town hall in October 1945. The hall was festooned with the flags of the independent black countries, Haiti, Liberia and Ethiopia, with a large map of Africa and anti-imperial slogans such as 'Oppressed Peoples of the World Unite' and 'Africa for the Africans'. Manchester had in part been chosen because a leading light in the Pan-African Federation, Guyanan born Ras T. Makonnen, was based in the city and had a network of restaurants and clubs that could provide food and accommodation to the 87 delegates.

These included stellar figures from Africa and the diaspora, including Kwame Nkrumah (later president of Ghana), W.E.B. Du Bois (famed African American writer and activist), Jomo Kenyatta (later president of Kenya) and George Padmore (leading Pan-Africanist ideologue from the Caribbean). One of the sessions was chaired by Jamaican-born feminist and Pan-Africanist, Amy Ashwood Garvey, leading light of the Universal Negro Improvement Association (UNIA) founded in 1914 by her then husband Marcus Garvey: she gave the only paper of the Congress on women's rights. On 16 October, the congress discussed 'Imperialism in North and West Africa' and Nkrumah advocated direct action to wrest control from the imperial powers: Africans should 'fight ... by revolutionary methods Seizure of power is the essential pre-requisite for the fulfilment of social, economic and cultural aspirations of colonial peoples.'[11] Later in the week Du Bois pithily summed up the radical nature of the gathering decrying the 'crazy idea of the white people of Europe that they should run the world for ever.'[12] This seminal meeting held only a few hundred yards from the Whitworth Art Gallery itself was a key turning point in the development of a Pan-Africanist agenda that shaped the post-war anti-colonial movement.

Len Johnson was there as a delegate from the local Communist party for whom he was to stand in six local elections over the next two decades (1947-62). The opportunity to take part in such a groundbreaking transnational political event inspired him and Communist friends to set up the New International Society in early 1946 which provided a social centre for Moss Side's multi-racial community in Ducie Street and was established in part to provide a bulwark against the recruiting activities of local fascists. Another inspiration had been the polymath, singer, actor and activist Paul Robeson who in the dark days of Johnson's boxing travails had met and talked with the fighter. He described how:

> Paul Robeson put new life in me with a few words. He drew me a picture of his fight for recognition. He pointed out that my job was fighting, and that if I could fight in the ring I ought to be able to fight outside it. I took his words to heart and made every effort to show that the British colour bar is just so much nonsense.... So I must thank Paul Robeson for helping me over a tough case of the blues.[13]

Johnson and his friends continued their international campaigning after the departure of the Pan-African Congress delegates and it was Robeson who they invited to speak and sing to further their campaign to save the lives of the Trenton Six who were on death row in the United States. Robeson was not content to speak and sing to the 4,000 ticketed folk at the King's Hall, Belle Vue, in May 1949, but insisted that he should come to the New International Society in Moss Side to engage with people brought together by his friend Johnson. His arrival sparked a mass crowd scene so intense that police horses were deployed to keep order outside the club. After a private talk and performance to the club members inside, he insisted on singing to those outside on the street. This impromptu concert sealed his affection for the city which he described more fully in 1956 in words recorded for a meeting in Manchester to campaign for the return of his passport taken away because of his communist sympathies. After likening his sojourn to that of Frederick Douglass, a hundred years before, his

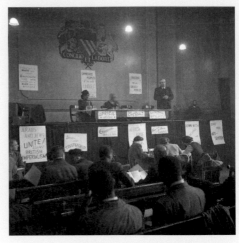

Fifth Pan-African Congress, 15 to 21 October 1945, All Saints, Manchester
Photograph by John Deakin
Image courtesy Picture Post, Getty Images

11. Marika Sherwood, *Manchester and the 1945 Pan-African Congress* (London: Savannah Press, 1995) p. 34.

12. ibid., p. 38.

13. Michael Herbert, *Never Counted Out!* p. 71.

words, linking the plight of the slave to that of the industrial worker, show how Manchester and the industrial North West provides a human link between toilers that is a counterweight to the oppressions of capitalism and imperialism.

> I can never forget that it was the people of Manchester and of the other industrial areas of Britain who gave me the understanding of the oneness of people – a concept upon which I have based my career as an artist and citizen. I recall how a Manchester friend explained to me how closely together we were bound by the web of human suffering and inspiration. He told me of the life of bitter hardship and toil which his father and grandfather knew in the mills – those dark satanic mills which (William) Blake cried out against in words of fire – and of how the cotton which his forefathers wove linked them with other toilers whose sweat and toil produced that cotton in far-away America – the Negro slaves, my own father, my own people. [14]

14. Paul Robeson, *Paul Robeson Speaks: Writings, Speeches, Interviews*. Ed. Philip S. Foner (London: Quartet, 1978) pp. 409-10.

Paul Robeson's soaring rhetoric places Manchester as key to radical ideologies that link capitalist oppression to the slave system. His vision of a trans-national working class alliance frames hope for the future. African diasporan peoples rooted in Manchester or routed through there provide a series of compelling narratives that make links and supply backdrops to these West African artists exhibiting in the Manchester and Whitworth Art Galleries. From Olaudah Equiano and Ira Aldrige through Pablo Fanque, Henry Box Brown and Frederick Douglass to W.E.B Du Bois, Len Johnson, Amy Ashwood Garvey, Kwame Nkrumah and Paul Robeson they show a commitment to artistic praxis, showmanship and political endeavour that is exemplary and helps to make *We Face Forward* a show with deep historical resonances in its Mancunian home space.

Acknowledgements

This paper is intended to illustrate the long history of African peoples in Manchester and to work against accounts that begin black British history only after 1945. It is dedicated to those black cultural workers living in contemporary Manchester who continue the struggle and the creativity that helps to make the city such a buzzing place: Jackie Kay, Kuljit Chuhan, Suandi, Kevin Dalton Johnson and Peter Kalu.

Embedded in the Fabric
Christine Eyene

As is often the case with major international events, the London 2012 Olympics provides a nationwide platform for cultural exchange and engagement with different parts of the world. The staging of an African art exhibition in Manchester, however, is not just circumstantial, but draws on long-existing links between the city and West Africa. Although those ties were born out of the tragic history of the Triangular Trade on which it built its wealth, Manchester, like other large metropoli in the UK, counts among its inhabitants a long-established and still growing multicultural community. Against this background, it can only make sense that cultural offerings from public art institutions would reflect the diversity of their own population.

The showcasing of contemporary African arts and cultures in the regions also speaks to an ever-increasing presence and acknowledgment of the continent's art practices beyond the confines of its own borders. Indeed, quite a number of major shows devoted to this geographical territory have emerged over the last two decades. Each of them championing or challenging the discourses accompanying the arts of Africa, from the old debates on 'authenticity' to the more recent framing of African conceptualism. In fact, such is the volume of these exhibitions that one has reached a point where the question is to know what more there possibly is to say about African art, presented under this label, that has not been already explored or unpacked.

One could apprehend this exhibition through an ethnographic grid. *La Triennale: Intense Proximité*, Paris, 2012 directed by Okwui Enwezor, certainly indicates the relevance of such readings in contemporary practice. Likewise, a cultural or geographical prism could also apply. But this would only lead us towards sets of pre-determined interpretative frameworks.

What interests us here is rather to proceed from a premise of 'non-knowledge', to borrow from French author Georges Bataille, and shun the tone of certainty that characterises assertions expressed by field specialists. This piece is written from the perspective of a diasporic gaze, that does not place the arts from Africa and its diaspora on a level of cultural specificity, difference, or otherness. Devoid of such approaches, what remains is an enquiry into aesthetic and other sensory experiences contained in some of the works brought together as artistic manifestations from one part of a vast continent.

If Cottonopolis thrived on its cotton manufacturers and the textile industry, then thread and fabric appear as interesting metaphors to explore a transcontinental space transposed from the historical or factual, to the realm of visual subjectivity and abstracted signs.

We Face Forward, the title of this exhibition says, but not without awareness of a certain cultural heritage. Indeed the scope of the selection ranging from an older generation of very established artists to emerging practitioners does give a sense of filiation that could be associated with the image of the thread. One example can be found in the link between El Anatsui and Nnena Okore, the

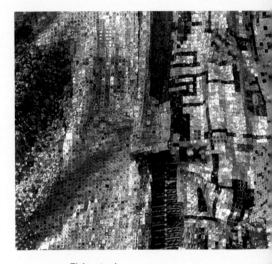

El Anatsui
In the World But Don't Know the World, 2009 (detail)

Aluminium and copper wire
Photograph by Jonathan Greet
Image courtesy the artist and
October Gallery, London

internationally acclaimed master and his independently successful student. But our thinking does not limit itself to an implied play on words between *filiation* and *fil*, the French for thread. What has been extremely captivating in Anatsui's work, for instance, is his ability to push the boundaries of the traditional meaning of cloth, and with it, the notion of fabric, textile and thread.

Anatsui's art – departing from his signature chainsaw sculptures in which, with exceptional craftsmanship, he used to incise signs and symbols drawn from his native Ghana, to the radiance of his majestic monumental cloths – finds no equivalent in the contemporary art scene. His metal fabrics evoke textile artforms anchored in African cultural and visual practices, but they also convey signs of today's global world. This goes from the workforce as a social class (in this respect, his atelier stands as a mini enterprise), to mass production of popular drinks sold globally; not to mention the usage of metal, its ecological impact and the resulting act of recycling which has been a longstanding practice in Africa well before the advent of mainstream discourses and policies on sustainability.

Of course one should not omit to mention how such humble materials as discarded cans and bottle tops have become unique coveted works of art, reaching some of the highest levels of the international art market. Which, for an African artist who has chosen to remain on the continent, in Nigeria, and share his knowledge with a younger generation of artists, is a most exceptional achievement.

This brings us to Nnenna Okore, US-based Nigerian artist mentored by El Anatsui. While the latter's works hang as massive wall-occupying pieces, Okore's art adopts a much lighter physicality. Again, one finds experimentations with fabric through various materials: 'newspapers, ropes, thread, yarn, fibers, burlap', to quote the artist, treated with clay, dye, coffee, starch and other elements.

To pursue our comparison, whereas Anatsui's practice is strongly associated with the idea of residue sitting in landfills across the world, of lasting material needing to be reused, Okore's pieces, with their organic feel, reflect the notion of biodegradability, somehow echoing the fragility of art objects to be cared for with extreme precautions. Of interest to us are also the particular net-like features of some of her works. Playing with suggested volumes and emptiness, their fluid forms convey a sense of movement. The patterns traced by the threads can also be interpreted as abstract signs to which the artist ascribes meaning and aesthetic value. Perhaps one could read in the delicateness of Okore's fabric the softness of a feminine touch. But we shall let the viewers judge for themselves.

Another example of grand textile production by an artist involved with the passing on of knowledge to a younger generation is to be found in the person of Abdoulaye Konaté, a pioneering practitioner who is also director of one of the best art schools in West Africa. Konaté's large pieces address both the local and global by combining African symbols and cultural codes with references that speak to international viewers. As such, his work becomes the medium of both 'abstract' signs and figurative forms referencing both historical and current topics, and highlighting his concern with socio-political issues.

While the human body has always been a prominent figure sewn, woven or patched onto the fabric, some of his most extraordinary pieces show his strong

Nnenna Okore
When the Heavens Meet the Earth
2011 (detail)
Burlap, dye and acrylic
Courtesy the artist and Robert Devereux Collection

sense of the material, whereby the textile becomes a motif in its own right. Overlaid fibres, strips of cloth, and shades of colours dyed by local artisans, compose colourful variations most pleasing to the eye. Their visual impact equals the urgency of the message, comment or observation embedded in the fabric.

Shifting our experience from three-dimensional space to image plane, Mohamed Camara, also hailing from Mali, takes us from the idea of textile as an artform to the fabric as compositional element. The photographer's interest in indoor settings began with the difficulty for him to take pictures outdoors. Turning this setback into a creative asset, his pictures depict some of his thoughts and capture the anecdotal fragments of narratives snapped through the lens of his camera. His interiors are intimate poetic moments in which the viewer is allowed access.

Looking to expand on the narrative elements of his imagery, Camara began exploring video as a medium. *The Curtains of Mohamed (Les Rideaux de Mohamed)*, was developed along this line of enquiry and records activities taking place in a room. The curtains function in the same manner as windows and doors in some of Camara's well-known photographs. Here, they serve as ambiguous space dividers separating the inside from the outside, the private from the public. But they also let through light and shadows, and glimpses of the outside can be caught through the movement of curtains. The translucent drapes also resonate with the notion of veiling, in that figures remain anonymous, only revealing their silhouette or parts of their body.

This act of concealing and unveiling marking the relationship between the cloth and the body is also found in the images of Brussels-based Togolese photographer Hélène Amouzou. Like Camara, her pictures are taken in a closed environment, an attic, giving her the privacy and freedom to experiment with self-portraits dressed up or in the nude. The intimacy of the context is rendered through fuzzy shots in which the blur acts as a grainy veil.

Amouzou often uses props in her settings: flowers in a vase, a crutch, a shoe, a picture frame, wooden furniture legs, suitcases and, most significantly, her dresses. These modest gowns convey multiple layers of interpretation. As clothes they perform their direct function, to cover up Amouzou's body, but also stress gender specificity both through their shape and, in one example, the printed flower design. In some cases, these motifs echo other graphic elements in the picture field. For instance, in one of her photographs the oblique shapes of a black dress are parallel to the beams, window frame, and rays of sunshine coming through the window. Likewise, her floral dress easily blends with the flowery wallpaper in the background of a series of pictures. The dress becomes a prominent feature, one could almost say a figure, photographed as a subject in Amouzou's 'still-lives'. Pictured on their own, the dresses cast the dramatic presence of Amouzou beyond her own body. They can also be read at the beginning or the end of a three-phase visual narrative staging Amouzou naked, wearing a dress, and the bodiless dress.

Between those three stages, in an undefined order, appears the photographer's vanishing body, a ghost-like presence matching her existence at the time as an

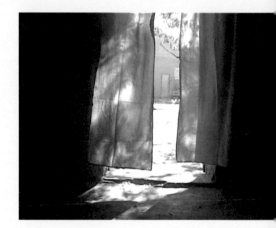

Mohamed Camara
The Curtains of Mohamed (Les Rideaux de Mohamed) 2004 and 2012 (still)
Video
Image courtesy the artist and Galerie Pierre Brullé, Paris

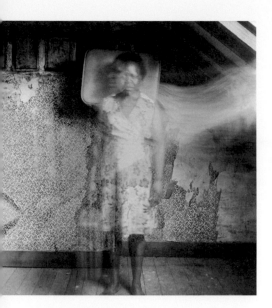

Hélène Amouzou
From *Self Portraits Series (Série Auto-portraits)* 2008 – 2009
Photograph
Image courtesy the artist

'illegal immigrant' with limited outdoor movement, a non-citizen in a status of transit, uncertain of the future ahead.

These are some examples of works presented in *We Face Forward* allowing the viewers forms of interpretations reaching beyond the mere ethnographical, cultural or anecdotal. Indeed, what we too often encounter in exhibition catalogues are writings attempting to frame productions by artists from Africa and the diaspora in such manner that they would be readable to a Western audience through a didactic grounding facilitating the translation of idioms stemming from 'Other' cultures.

The only narrative on which we chose to focus in this essay is the *narrative thread* in a metaphorical sense. To dwell at length on the circumstances that have woven the story of such a significant fibre as cotton – with the dramatic costs historically acknowledged – will not change the course of past events. But maybe forms of reconciliations can take place, at least in the cultural field, since this is the context discussed here, with some license given to subjectivity.

It must be said here that, although our interest in fabric and thread seems to coincide with *Cotton: Global Threads* recently held at the Whitworth Art Gallery, it actually grew independently from this exhibition. Whereas *Cotton* looked at the 'global history of the production, consumption and trade in cotton' and therefore was historically, geographically and economically contextualised, I here aim to consider the physical material, the fibre, the thread, as neutral graphic signs appropriated by the artists for the sake of their own aesthetic research.

In this respect it worth noting that the Whitworth continues exploring the history of the fabric through the work of Nigerian artist Victoria Udondian. While her practice is mostly research-based – drawing from archival material, the history of textile, the early days of the Nigerian fashion industry and the impact of second hand clothing – these translate into installations in which conceptual orientation is set to extend to fictional narratives.

Contemporary African art has been present in the global art scene long enough for imaginary forms stemming from creative minds to be apprehended first and foremost through the intrinsic nature and the intricate relations between form, medium and space, before being loaded with the burden of history and cultural specificity. This essay seeks to encourage such approaches to the writing on contemporary African art practices just as it is applied to the arts from other regions of the world.

Filling The Voids:
The Emergence of Independent Contemporary Art Spaces in Africa
Koyo Kouoh, Raw Material Company, Dakar

As a general rule, the type of administration inherited from colonial systems and perpetuated by political and administrative elites in Africa did not put an emphasis on private initiative. This is especially true in the arts, and the situation is particularly pronounced in former French colonies, heirs to a centralistic model of the omnipotent and omnipresent state that considers its role to be the initiator, the regulator, the controller, the promoter, the producer, and the critic. This has fostered a culture that is not conducive to the development of a strong civil society, or a thriving cultural private sector. On the contrary: it discourages any progressive effort to bring to life models of artistic intervention that set knowledge production and critical thinking at their centre, and that do so while working outside such established and recognisable spheres as the university and the art academy. Moreover, the institutional and structural layout that governs the arts provided a vicious ground for breeding artists who were both intellectually and financially dependent. In such a system, art professionals were obliged to pursue careers as civil servants, as that seemed the only way into cultural action. The model of the ministry of culture and its various departments, divisions, agencies, and endless committees thus became the power plant in whose chambers the national artistic identity was forged.

One cannot deny, certainly, the important roles played by spaces of knowledge and production such as the University of Nigeria at Nsukka, University of Ibadan, Nigeria; Académie Nationale des Arts in Abidjan, Ivory Coast; and Kinshasa, Democratic Republic of the Congo or Ecole Nationale des Beaux Arts in Dakar, to name but a few, in the two decades following the independences in the 1960s. In 1966 the first Festival of Negro Arts (*Festival Mondial des Arts Nègres*), organised in Dakar by former president Léopold Sédar Senghor of Senegal, is still considered to be the authoritative cultural landmark of postcolonial Africa, and it remains an inspiration to multiple generations of artists, writers and intellectuals from Africa and its diaspora. The space for artistic (re)presentation and production and intellectual criticism was an immensely fertile ground. It bred cutting-edge literature, theatre, cinema, and art historical criticism that gained, and deservedly so, the respect and recognition of national and international audiences. The art department established at Makerere University in Kampala by the then young East African Union, comprised of Kenya and Uganda, is another example of the visionary ambitions nurtured in the years following the 1960s. It is sad, though, to witness the crumbling of these rich legacies. Recent visits to these institutions and conversations with students and faculty bring to the fore the rallying cry for access to tools and funds. Artists and affiliated professionals roar this cry in unison across Africa.

In her critically acclaimed essay *Le viol de l'imaginaire* (*The rape of the imaginary*), published in 2003, Malian economist, social scientist and active patron of art and design, Aminata Dramane Traoré, states the following, 'it is over

forty years now that Africa has desperately been trying to get out of a deadlock. Africa tries to find a way out of the discourse established by those who taught her to think of herself as poor.' Traoré insists that, more than private investment and modern technology, Africa needs to recover the immaterial part of herself, that which has been ripped off: her dignity. Africa's immaterial part is its imaginary and the artistic and intellectual production that is in charge of the imaginary.

The void that ensued became the ground from which rose independent organisations, such as doual'art, established in Douala, Cameroon in 1992, and the Townhouse Gallery, established in Cairo, Egypt in 1997, with cultural and artistic ambitions. Many others followed in the early years of this century. The inventiveness, courage and resilience of these initiatives are strong proof that art and creativity is a fundamental human need that can thrive within any given political or economic condition. The emerging scene of private art institutions and centres shows the commitment to artistic interventions from historical, contemporary and prospective perspectives. Whether large or small, well funded or not, centres such as these are changing the cultural and artistic landscape; if nothing else because they are filling the dearth of spaces of free expression, production, exhibition and reflection. They are, in essence, reversing the *tabula rasa* mentality that characterizes the approach, by Africans and non-Africans alike, towards contemporary artistic production on the continent. This attitude has been particularly strong among lovers and connoisseurs of traditional African art, who tend to consider contemporary African art to be a mere replication of European artistic practices that have been stripped of any recognisable reference to what they think is 'authentically' African.

As art centres in the West are bending under the strain of budget cuts and threats of closure, there are more and more of them opening elsewhere in the world. If things go smoothly in terms of political and social transformation there is an assurance that the world outside the Western one will produce enough wealth to give rise to new sophisticated creative people able to challenge the most advanced artists of the Western world. There are new canons, new markets, new dialectics and most important a highly-educated audience. This trend is especially noticable on the African continent, where during the last decade a variety of independent, private art initiatives has emerged to fill the vacuum left by unfulfilled promises of cultural and artistic programmes led by governments.

These initiatives generate highly-welcomed knowledge and experience in the local artistic and intellectual biotopes in relation to continuity, a re-assessment of contemporary history and, in challenging the canons, geographies and master narratives of post-colonial schemes of artistic action. The limited idea of national representation is now challenged by the shifting weight from the idea of power to the idea of content. Two moving forces of cultural exhibition are displaying an engagement for agency that has its roots in the (infra)structural layout established since the 1960s. Content and relevance become imperative tools in organizing the new flows of ideas and productions. The role of art institutions and initiatives is changing in relation to broader artistic urgencies, and in relation to society in its entirety. In recent years the evaluation of a founding principle of many independent organizations that have emerged is that independent

contemporary art institutions are an important voice in the construction of a strong cultural private sector as well as in forging a critical opinion from an open civil society.

The importance of issues of action, space, power, control and quality become central. What kind of intellectual and artistic society can be imagined, given the recurrent political and economical setbacks that cause continual disruptions in the development of visions in Africa? The view these sites offer aims at feeding the debate on the issues that surround African artistic practices, as these are experienced today. It aims to show the contagious dynamism of African cultural producers. It is a statement about the art institution as the ultimate power player in the construction of a cultural environment. These emerging voices of freedom stand as brave models for how to fill in the institutional voids I mentioned earlier. They excavate, they produce, they educate, they display, they (re)connect, they document, they preserve, they analyse and they share. They simultaneously create and host a critical mass for a healthy intellectual and creative competition that is necessary for the rise of an influential civil society and the formation of citizenship and pan-African identity. There is no doubt that this significant development contributes to progress in the field of contemporary art.

We are Us not Other
Lubalna Himid

Lubaina Himid has been a fellower traveller during this project. Her open letter makes present those British artists of African descent, many of whom are on our doorstep.

Dear Caroline

I won't repeat the joke Susan told me about artists not being special at all but just being people who know the difference between beige, ecru, cream, off white and eggshell. It would be better to start with a serious quote and then try to turn it upside down the better to explain how, and why, I am still so determined to look at the way that the four-pronged conversation in Britain between the artwork, the artists, the participants and curators can develop from the disjointed and interrupted misunderstanding it still too often is even now, into a passionate and enriching conversation that engenders a real sense of belonging in all of us.

> People are only interested in themselves. If a story is not about the hearer he will not listen. Here make a rule; a great and lasting story is about everyone or it will not last. The strange and foreign is not interesting, only the deeply personal and familiar.
> John Steinbeck

In the art place however, what may seem strange and foreign to some curators can be deep and personal to some participants. Art from West Africa, for instance, is not strange and foreign if you have lived in West Africa or if your ancestors came from West Africa. The story is not strange or foreign either if you have ever looked at work by Yinka Shonibare or Chris Ofili or Claudette Johnson, Keith Piper, Sonia Boyce, Jessica Longmore, Paul Clarkson, Marlene Smith, Harold Offeh or Raimi Gbadamosi, Barbara Walker or Chantal Oakes.

Art from West Africa might be deeply personal and familiar to everyone who has ever considered the lasting impact a visual output might have that explores family or landscape, or which looks at history or memory, or which tries to understand the sublime or the uncanny, the body or the everyday; everyone who has ever considered that visual art and creative practice might be at all interesting.

The best artists make art to forge surprising, yet long lasting, connections with people, both foreign and familiar, to reveal insights and to make juxtapositions, to astonish and to make the space for dreaming the impossible. They/we don't do it as a geographical group or as a homogenous cluster but because what we make is deeply personal and familiar to us. When work is gathered in a space using an umbrella term to focus the mind of potential audiences, it may seem misguided but the advantage is that many audiences may well be lured into visual dialogue because they think they will feel an affinity.

Keith Piper
Untitled 1986
Emulsion on canvas
Image courtesy Manchester Art Gallery

They may want to feel the desire to walk and talk amongst artworks from 'somewhere else' for many reasons: a) The experience is an opportunity for participants to see themselves not as 'other' but as they actually are; as themselves; b) The experience feels familiar, there is a sense of being listened to, of being understood; c) The experience feels unfamiliar, overwhelming, disconcerting and encourages questioning, relooking, or revisiting.

Sometimes the impact of an artwork takes years to penetrate, sometimes the shift is dynamic. No two meetings of artist, artwork and participant are ever the same, how could they be? The artist brings her story to the place, tells it via the artwork, the participant brings his story and re-remembers it via the artwork; often the two never meet, but speak in silence across the territory of the showing space. Sometimes the audience member is also a visually creative person (just as the ardent football fan often plays for a pub team on Sunday) she is bold about looking and expressing opinions and is an active participant. Sometimes the artwork is difficult to read, ambiguous, deceptively open and yet many layered. Sometimes the artwork is apparently simple to understand, clearly narrative, but with a story so secret and personal, it is completely strange and foreign to almost everyone.

Have you noticed how few bold and beautiful signs and notices giving clear directions there are in art spaces? Even though the place is teeming with visual people, looking intensely at what they can see in front of them? I've known of exhibitions, staged for reasons of funding, but which were completely unsigned, so were never found by new audiences. It's a horrible trick often played. You were right to complain last year when you couldn't find the show as it nestled in the belly of the beast, it's the only thing to do.

The very best thing about showing work in a space in a country, or a city that is not your own, is the opportunity to meet artists who work in the place themselves. It's so heartening to know that the town is filled with artists and participants who have a working relationship with the curators, collectors, scholars, students and friends of the venue. It's always so much easier then to build and develop further projects and to work with those in the know about local funding and support. The last thing you want, as an artist, is to visit somewhere once and then never go back. I love doing gallery and museum talks or practical workshops even, as part of a popular series which includes artists and collectors from the surrounding districts.

Over the years I've found that artists from dual cultures, living here in Britain have a peculiar and particular insight into things visual; they use such a multiplicity of language and have an overwhelmingly curious take on what can be seen. We/they always seem to need to look behind and beyond everything, lift everything up to check the mark, read the data, know the facts, see both sides, reach both sides, do too much, move to and fro between the forgotten wilderness and the bosom of the liberal left. We are not the only people who want to broker a deal between those that make work, those that show it and those who love to engage with it and watch it work in the art space. I am not the only person who witnesses the madness of curators who are only impressed by artists from somewhere else, when every artist comes from somewhere else

Yinka Shonibare
Boy on Globe 4 2011
Copyright Yinka Shonibare
Image courtesy the artist and Stephen
Friedman Gallery, London

Black Audio Film Collective
Handsworth Songs (stills) 1986
Image courtesy Smoking Dogs Films

somewhere. Artists from everywhere are happy if you love your own artists nearby for the way in which they keep conversations going.

Commissioning and collecting even modestly really helps the creative flow of things but in the 1980s a small set of 'artist clusters' set out to shift the way that our work was encountered. We actively wanted to make real and lasting connections with the people who might engage with our creative output. The groupings included The BLK Art group, Black Audio Film Collective, Sankofa, Obaala, Blackwoman's Creativity Project, D-Max and the women who exhibited as part of 5 Black Women at the Africa Centre, Black Woman Time Now and The Thin Black Line. We all in our different ways understood that audiences, participants, people, communities were equal to us and part of us and would question us and hopefully support us.

We and they were Us, not Other.

It was vital to us that our work then reflected the lives of the people looking at it. It was important that the venues in which exhibitions, films and events took place were free or very cheap to access. If they were publicly funded venues at the heart of the city, that they were easily reached by any community, or else, that they were located at the heart of particular communities, and spoke directly to the surrounding landscape of the everyday.

Those of us who selected, organised and self-funded these late twentieth century visual art events thought, much of the time, about impact, significance and reach and did not wish to take into account the fleeting admiration of the market. This was not because we occupied the moral high ground nor were we privately wealthy; we were fixed on the longer term strategy of getting our voices heard right across the full spectrum of cultural activity and then seamlessly belonging/becoming 'inside' the history in order to change it. We were not curators and did not own or make or write or speak the theory, we were almost all cultural activists whose aim it was to bring people, via a dialogue across artworks, nearer to a state of belonging. We were committed to making a place in which each person's voice was equal to another.

Although many of the young black creative practitioners at the heart of this dramatic shift during the last two decades of the 20th century were educated in British art schools and departments, we had not always been very comfortable there or wholly successful in dealing with the complexities of teaching and learning via 'show and tell' which still to this day drives life in the studios. We did not automatically find work in the art school on the completion of our degrees, as part of the army of part-time tutors holding the institutions together then. This situation was a blessing in that we had to get out there into the city and make things happen and, of course, it was a curse, because we could never rely on a regular salary to fund our making. It meant that we had to speak to, and show for the people we knew who were interested in the visual and interested in the political, but who would not always have called themselves art audiences.

There are curators and historians who mourn in retrospect that we, the black artists who emerged in the 1980s before the YBA generation, are both lost and invisible. I have been known myself to describe what it feels like to be 'inside the

invisible' in both texts and performances but this could be a mistake. Invisible to whom we are invisible? Not to myself, and not to each other. We know who we are and where we are. It is surely also true, but little commented upon, that we are very visible in the work of extremely successful and wealthy artists showing across the world today.

My view is that there would be no Yinka Shonibare without Sonia Boyce and her masterly control of pattern and person. There would be no Chris Ofili without Keith Piper and his dramatic expression of what it is to be a black man, that there would be no Steve McQueen without Isaac Julien, that there would be no Tracy Emin without Maud Sulter. There would be no Institute of International Visual Arts (Iniva) without Obaala, Talawa, Sankofa or Black Audio Film Collective.

Akira Press, Urban Fox Press, Third Text and Black Arts in London helped us tell each other where to find each other, how to work with each other, and how to grow artists and audiences into participants in a gradual but solidly sustainable, constantly changing, more integrated way of engaging culturally. We invented the practice of respecting the fact that audiences are everywhere and love to participate in discussion and debate, and that it is fine to take the work out of the gallery, while at the same time insisting that we show there if we want to.

Americans like Betye Saar and David Hammons, Faith Ringgold, Beverly Buchanan and John Outerbridge showed us that we were by no means the first to actively engage through making and showing with the people who we knew, who were family, or lived in our neighbourhoods. However, the artists at the heart of the groups here that I have listed had to invent a particularly 'local' strategy for the way we could communicate via the cautious and distant, discretely closed environment of the galleries and museums in the Britain of that time.

It has taken many years to be able to openly discuss and then try to influence acquisition policies on behalf of each other. We can now fight for the necessity of being present in the archive, all the while continuing to preach the importance of multi-layered communication. Global funding calamities, young and enlightened curators, numerous technological breakthroughs, good luck, longevity, loss and creative strategies have made it possible. Strangely it is only possible to really experience the dynamism of these dialogues, while taking part in the event, at the screening or wandering around inside the installation itself. You cannot just read it, you have to be part of it.

Forgive me if I seem to have said these things to you too many times recently, but I hope writing it down might make it more useful to you.

All best wishes
Lubaina

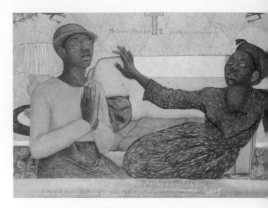

Sonia Boyce
Missionary Position II 1985
Copyright Sonia Boyce
Image courtesy the artist and Tate

Artists

Georges Adéagbo

Georges Adéagbo's complex installations have been described as an 'archaeology of knowledge'. Tracing particular notions, or relationships, through found objects, records, posters, books and clothes, shown alongside specially-commissioned paintings and sculptures by local Beninese artisans, Adéagbo communicates his own trajectory through culture and history by mixing his personal stories and those of friends and relatives with major events in world politics and famous personalities.

In 1999, Adéagbo created *The Story of the Lion* in Venice – an installation in front of the entrance to the Arsenale, which was the gateway to the Mediterranean and Northern Africa. He created narrations concerning domination through military power and trade, around and in front of the four Lion statues that the Serrenissima had confiscated. The event was produced by jointadventures as an independent satellite event, and incorporated at the last minute by Harald Szeemann into his 48th Biennial. Adéagbo was given an award of the Jury for this work.

Each installation is produced for the specific site of its exhibition, incorporating archival and found material from the immediate surroundings. At the Whitworth Art Gallery Adéagbo's installation *The Becoming of the Human Being...* illuminates and traces relationships between Manchester and Cotonou, via the wider context of the UK, France, America and Africa. Laid out in a museological, or shrine-like display, the objects and Adéagbo's own notes lead visitors to make connections between the specific and the universal, as conducted by Adéagbo's associations and juxtapositions.

Georges Adéagbo
The Becoming of the Human Being, Talking about the Destiny of the Human Being, and Showing the Destiny of the Human Being. The King of England and the Queen of England. (Le devenir de l'être humain, parlant du destin de l'être humain, et faisant voir le destin de l'être humain. Le roi d'Angleterre et la reine d'Angleterre)
Mixed media
Installation at Whitworth Art Gallery
Photograph by Michael Pollard
Image courtesy the artist and
Stephan Köhler/jointadventures.org

Hélène Amouzou

..

'Self-portraiture is a way of writing without words. My aim is to reveal the deepest parts of myself.'[1]
Hélène Amouzou

Hélène Amouzou works with the medium of photography to create ephemeral and ghostly self-portraits. She captures herself or her belongings (often her clothes) in an empty room with peeling floral wallpaper. In many of the images she includes a suitcase as a recurrent symbol of her state of flux and transit. The photographs were taken during a two year period when Amouzou was seeking asylum in Belgium and waiting for her official residency visa.

Amouzou acknowledges the influence of American photographer Francesca Woodman (1958 – 81) but she produces her own distinctive and haunting imagery, which speaks of the contemporary issue of the displacement of people and those in exile. She works with film rather than digital media, preferring the effects of chance and serendipity and she exploits the use of long exposures.

These photographs reveal a constant questioning and search for the subject's identity. Notions of freedom and legitimacy are explored in a world of bureaucracy and inequalities. Amouzou captures feelings of exclusion and of being stigmatised by the lengthy official process. Those with permanent residency rights can only imagine the insecurity and daily worry about the possibility of being sent back to an unsafe place and Amouzou's photographs reveal this sense of impermanence. Her ghostly image haunts each frame and hovers in the no man's land between absence and presence.

..

1 Featured in *Hélène Amouzou: Autoportraits*,
 15 September 2011, Another Africa
 online. Available at www.anotherafrica.
 net/featured/featured-helene-amouzou
 [accessed 12 January 2012].

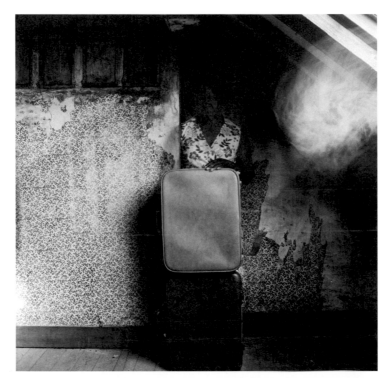

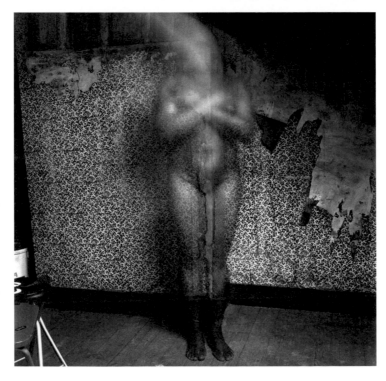

Hélène Amouzou
Selection from *Self Portraits Series
(Série Auto-portraits)* 2008 – 2009
Photographs
Images courtesy the artist

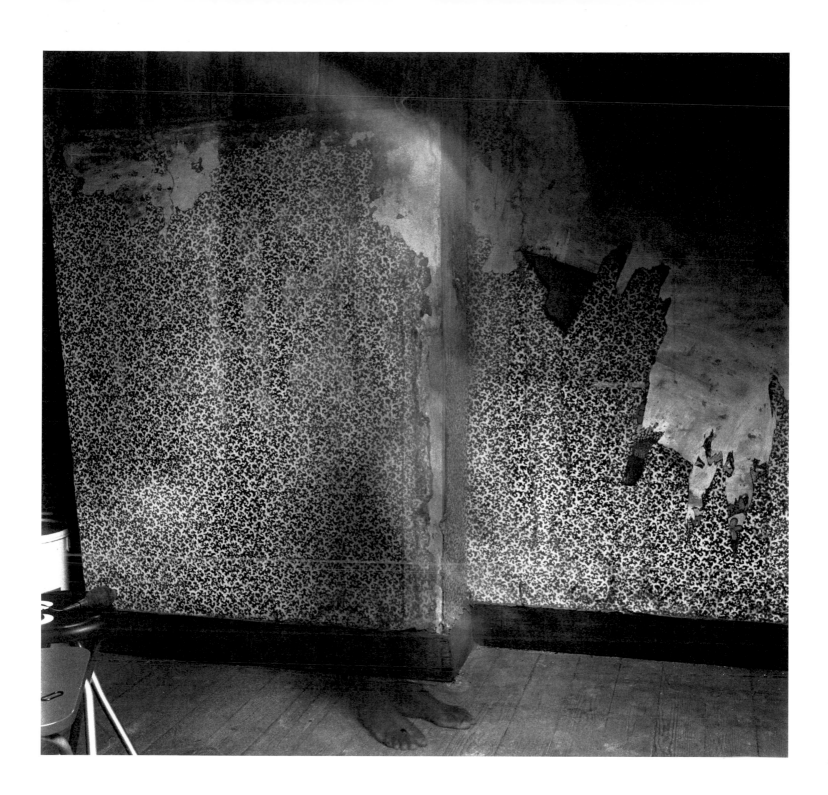

El Anatsui

Imposing in scale, sumptuous in colour and texture, and yet produced from everyday materials, El Anatsui's works are as visually rich as they are laden with associative possibilities.

Anatsui's hanging sculptures of exquisite colour and delicacy, such as *In the World But Don't Know the World*, are made with aluminium wrappings and bottle-caps. Anatsui resists the description of his works in terms of 'recycling', he is instead interested in the metamorphosis that materials undergo; metal becoming a fluid and fragile textile, and discarded waste transformed into a beautiful and precious work of art.

Rather than professional art materials, Anatsui chooses to work with found objects, saying 'I don't think that working with such prescribed materials would be very interesting to me – industrially produced colours for painting. I believe that colour is inherent in everything, and it's possible to get colour from around you, and that you're better off picking something which relates to your circumstances and your environment than going to buy a ready-made colour.'[1] By using these found materials, Anatsui's works resonate with the history and meanings inherent in the objects he chooses. Alcohol was a commodity that Europeans traded for slaves in West Africa and major European companies were founded on the wealth produced by exporting gin, schnapps and brandy to Africa.

Textiles too have a rich history, both as an object of trade between Europe and Africa, but also as a physical record themselves. Anatsui has said '...[i]f there were a direct link between the bottle caps and textile cloth it would be that they bear names referring to incidents, persons, to historic or current themes. Take, for instance, the Ecomog Gin: it takes its name from the regional rapid deployment forces that terminated the wars in Sierra Leone and Liberia... Similarly, Kente draperies carry names such as "Takekpe le Angola" ('conference in Angola') or they are named after characters.'[2]

Anatsui realises his enormous works with the help of a team of assistants, but he does not create a sketch for them to follow, instead wanting the materials to take the lead. '[The assistants] are more a part of the process; they are not all the time just hands. Working this way, I have got to understand both the material and the different touches or styles of each assistant. It is like conducting an orchestra of musicians each with peculiar performing skill.'[3] Once completed the works are never fixed, but are reconfigured for new locations and environments, forever changing and renewing.

............................

1 El Anatsui, *Asi* (David Krut Publishing in association with October Gallery, 2006) unpaginated.

2 El Anatsui as quoted in Britta Schmitz 'Who Knows Tomorrow – Who Knows Today' in Udo Kittelmann, Chika Okeke-Agulu and Britta Schmitz (ed.) *Who Knows Tomorrow,* Berlin (Verlag der Walther König, 2012) p.xx.

3 El Anatsui, *Asi*, unpaginated.

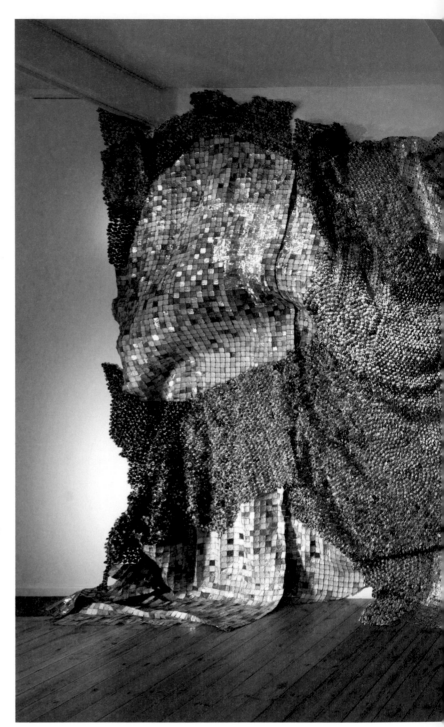

El Anatsui
In the World But Don't Know the World 2009

Aluminium and copper wire
Photograph by Jonathan Greet
Image courtesy the artist and
October Gallery, London

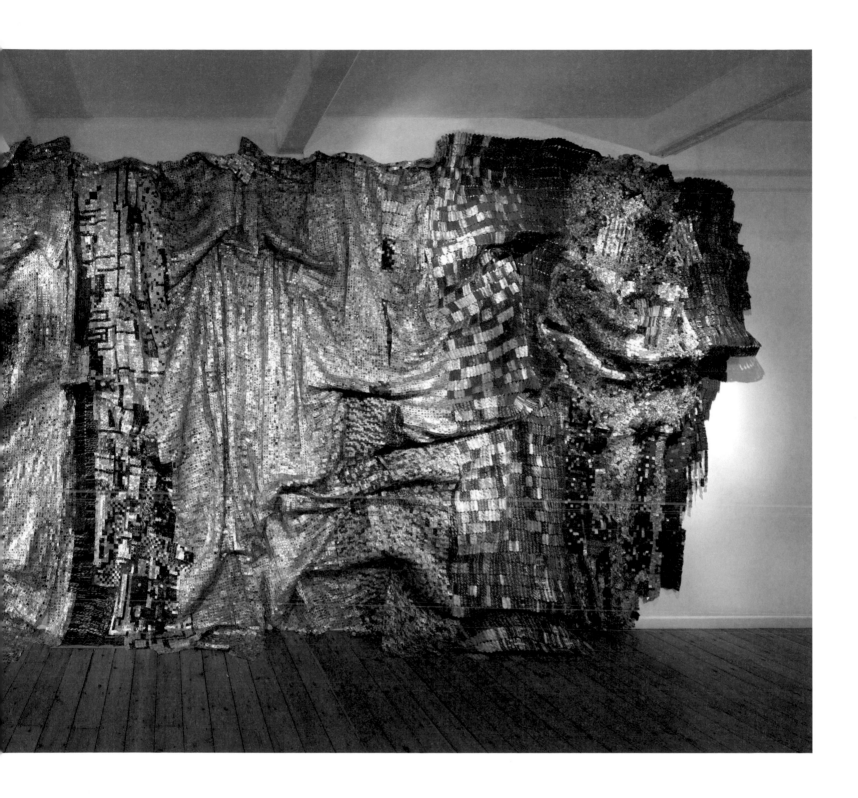

Lucy Azubuike

Taken from the *Wear & Tear* series, Lucy Azubuike's collages are inspired by her observations of the changing colours and compositions of advertising hoardings in Nigeria. 'Posters pasted in every nook and cranny of our roads and streets often metamorphose into something else through the blend of wear and tear by humans and the effect of weather. The resultant effect is often a magnificent painting, caricature, or abstract form of colour and imagery.'[1]

In the *Wear & Tear* series Azubiuke uses found posters, pages from magazines and paint. Mirroring the processes the posters undergo, her works are left in turn to bake in the sun, and soak in the rain. Interested in employing and revealing the creative potential of chance occurrences, Azubuike became a student of El Anatsui's and continues his assertion that 'it's possible to get colour from around you', [2] but she chooses for her palette the material evidence of increasing commercialisation, the cheap and prevalent images of advertising.

Manipulating these materials and subjecting them to processes of chance, Azubuike's collages evoke rich and varied visual associations, camouflage, peeling skin, a blazing sun. As Azubuike asks, 'it's not just a matter of seeing these things, but asking where do these images lead you to?'[3]

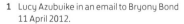

1 Lucy Azubuike in an email to Bryony Bond
 11 April 2012.

2 El Anatsui, *Asi*, unpaginated.

3 Lucy Azubuike in an email to Bryony Bond
 11 April 2012.

Lucy Azubuike
Selection from *Wear & Tear* series:
Clockwise from top right:
23 2011
24 2011
21 2011
Collaged paper, gouache on canvas
Images courtesy the artist

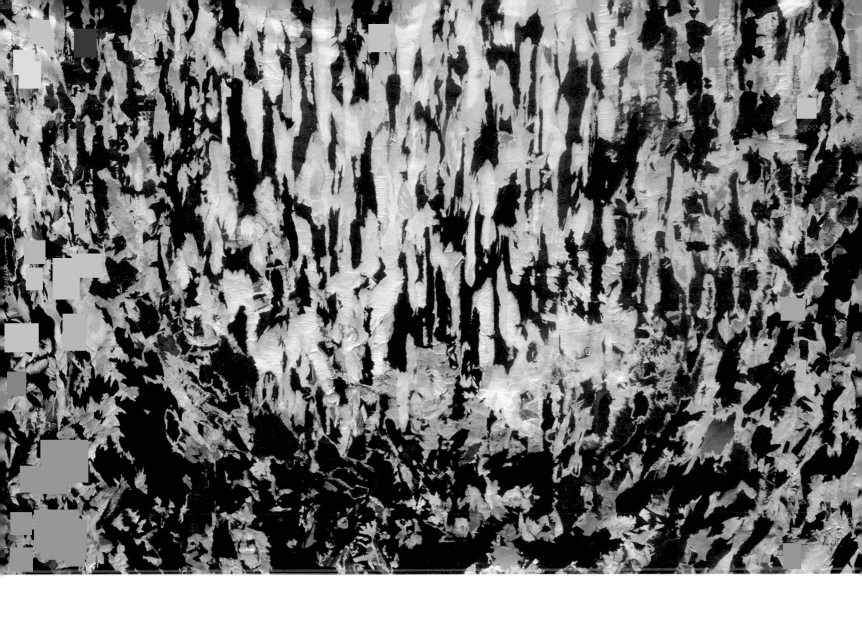
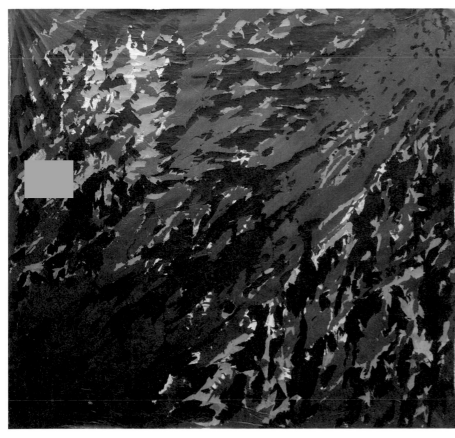

Mohamed Camara

Mohamed Camara started his career taking photographs on a borrowed digital camera in Bamako, Mali in 2001 aged sixteen. After nearly having the camera stolen, he retreated into his own four walls and pointed it at the windows and doors. The resulting images *Malian Rooms (Chambres Maliennes)* 2001-02 show his friends and family engaged in everyday tasks in the interiors of their shadowy houses with blinding light piercing the windows and doorways. Without any knowledge of 20th century art or any training in photography, Camara was instinctively drawn to classical motifs of sleeping figures, windows and drapery, recalling interiors by Pierre Bonnard or Henri Matisse, and had an intuitive understanding of Henri Cartier-Bresson's 'decisive moment'.

The film *The Curtains of Mohamed (Les Rideaux de Mohamed)* 2004 was made a few years after this series, but relates directly. With a fixed viewpoint, Camara focused on different doorways, using them like a theatre stage and arranging the light, colours, objects and actors. With an absence of narrative, he presents intimate depictions of domestic interiors and people and animals going about their daily business. The film focuses on the interactions around the floating drapes that hang in the doorways of houses and poetically captures the contrast between interior and exterior, light and dark, heat and cool, sun and shade, public and private.

Camara said 'There was something unsatisfying about the fixed image (of the Malian rooms), because there's so much going on in and around these rooms. That's why I wanted to make this film, which expresses time, patience, etc. When the Malians saw the film, they were surprised, because in Mali, when you agree to be filmed, it's in order to see yourself, and in this film the people aren't seen – they're just silhouettes, or their faces are outside the frame....'[1]

..............................

1 Mohamed Camara: Photo en Développment, (Editions de l'oeil, 2008) p. 74.

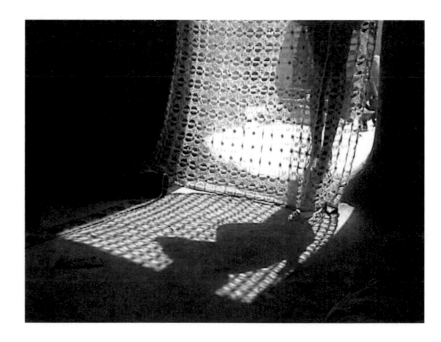

Mohamed Camara
The Curtains of Mohamed (Les Rideaux de Mohamed) 2004 and 2012 (stills)
Video
Images courtesy the artist and Galerie Pierre Brullé, Paris

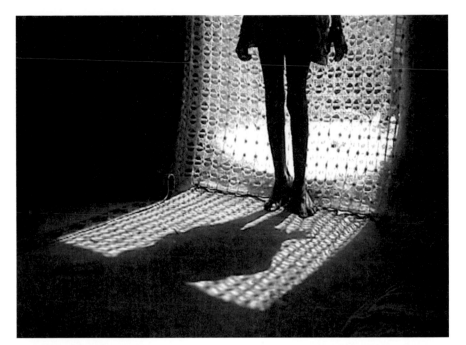

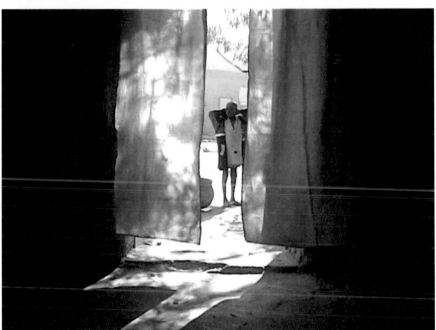

Em'kal Eyongakpa

Em'kal Eyongakpa originally studied plant biology and ecology. In addition to his interest in the environment, his mixed media installations, video, photography and performance also explore human conditioning, identity and the creation and consumption of information and ideology. The title of Eyongakpa's multi-screen video work, *Njanga Wata*, comes from the pidgin English translation of the Portuguese, *Rio dos Camarões*. Meaning river of prawns, *Rio dos Camarões*, was the name given to the coast of Cameroon in the 15th century by the first Portuguese explorers and is the root from which the word Cameroon derives. Declared a German colony in 1884, Cameroon was divided between France and Britain after World War I. Although the French and British Cameroons came together in 1961, linguistic and political divisions remain. Eyongakpa observes how this history still impacts Cameroon, 'being a state with one of the highest levels of literacy in Africa, it is absurd to observe how the socio-political thought patterns are still so much IN-DEPENDENCE to its colonial masters.'[1] Through his work, Eyongakpa seeks to highlight the arbitrariness and irrationality of the imperialistic structure of imposed languages and names, asking 'should people question who they really are irrespective of the names they are given?'[2]

Both symbolic and surreal, *Njanga Wata* takes seriously the legacy of colonialism, but makes light of the absurdity too. The cycling figure in the river, his head a pool of prawns, constantly pedals, but ultimately gets nowhere.

1 Em'kal Eyongakpa in an email to Bryony Bond 16 May 2012.

2 Ibid.

Em'Kal Eyongakpa
Njanga Wata 2011 (still)
Video installation
Courtesy the artist

Aboubakar Fofana

Aboubakar Fofana was born and raised in Mali and went on to study and train in France and Japan. Whilst he remains strongly grounded in his Malian heritage, his artistic expression is a subtle alchemy of these three cultures which he calls his own. His work is a fusion of ancient African and Japanese weaving and dying techniques as well as calligraphy which results in a contemporary body of work which is both original and intrinsically universal. He has adapted traditional Malian mud-dying techniques to produce powerful abstract paintings on organic jute canvases; traditional strip-woven organic cotton, natural indigo and vegetable dyes are the source materials for his unique installations and sculptures.

One of the underlying and defining artistic concerns in his work revolves around his desire to maintain Mali's cultural heritage and preserve and revitalize his country's nearly lost tradition of natural Indigo and vegetable dying. He has relentlessly sought out the remaining old masters of weaving and dying, learning their skills. He has also planted organic cotton and indigo and has systematically encouraged local craftsmen to use natural dyes rather than chemical ones.

Obsessions, 2012 is a new work made especially for *We Face Forward*. Suspended from the ceiling in Manchester Art Gallery's airy glass atrium, numerous transparent linen panels hang, gently moving in the air. From top to bottom automatic writing has been painted onto each panel in mud. The text is not recognisable or legible and therefore does not have the meaning of language. Instead Fofana is passionate about the inherent rhythm of writing and the obsessional quality of subconscious inscription. The artist rejects a common misconception that there was no writing tradition in Africa before Europeans arrived and suggests that African civilisations used writing for different purposes than how we use it today. Drawing parallels to music, Fofana evokes the poetry in the motion of writing and the resonance of its trace.

Aboubakar Fofana
Obsessions 2012

Mud dye on linen
Commissioned by Manchester Art Gallery
Photographs by Michael Pollard
Images courtesy the artist

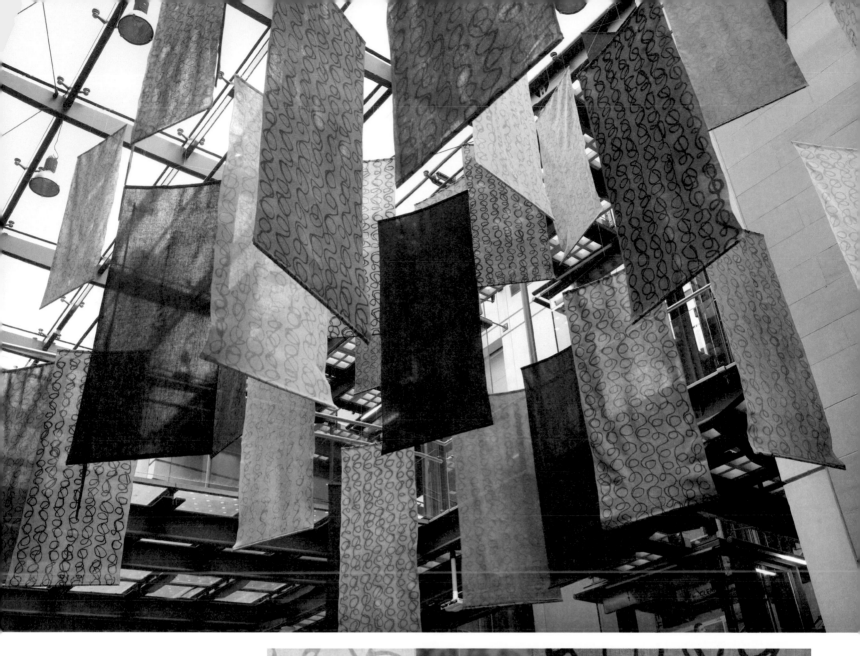

Meschac Gaba

...

Ensemble by Meschac Gaba, the flag and emblem of *We Face Forward*, is at once a bright playful quip and a sincere gesture of solidarity.

During the summer that the UK hosts the Olympic Games, symbols of competing national identity abound, but in *Ensemble* the boundaries of each nation are unclear. A starburst of all the flags of West Africa[1] together with the Union Jack, *Ensemble* is a blazing riot of nations combined, all emerging from, or converging into, a central disappearing point.

Ensemble closely resembles *Roulette*, a work made by Gaba for his ongoing magnum opus, the *African Museum of Contemporary Art*. Situated in the Museum's Games Room, *Roulette* combined international flags with a stick attached to a bicycle wheel. Able to spin the wheel visitors could win a ring from the artist if the stick pointed to the correct flag. A game of pure chance, *Roulette* was an international gamble: some nations won, others lost.

Gaba has been praised for his ability to 'modulate jest'. From braided headpieces shaped into architectural monuments, to *Sweetness*, a model city made of sugar, Gaba's playful approach conveys serious political undercurrents. For Gaba, *Ensemble* is his answer to the question he perceives in the exhibition's title, 'We face forward: but facing what? And how? I propose as a reply or solution to put all the countries' flags together, so that it becomes a symbol of unity, solidarity and friendship.'[2]

.............................

1 *Ensemble* also includes the flag of Cameroon, a country officially in Central Africa, but which is included in *We Face Forward*.

2 Meschac Gaba in an email to Bryony Bond 10 January 2012.

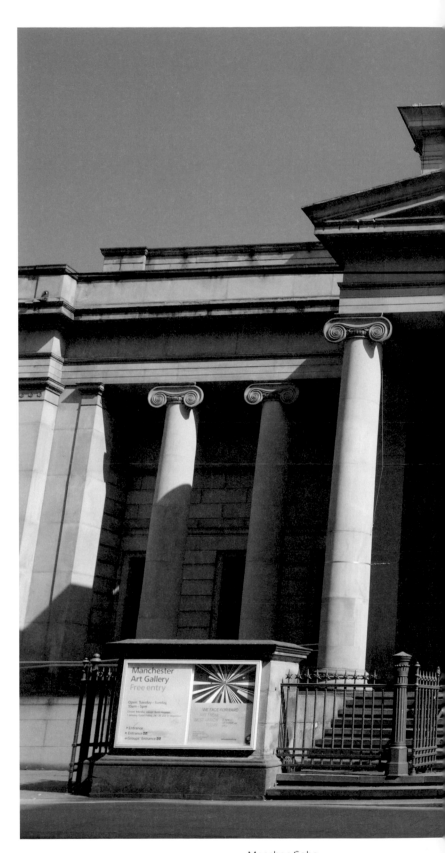

Meschac Gaba
Ensemble 2012

Flag
Installation at Manchester Art Gallery
Commissioned by Manchester Art Gallery
and Whitworth Art Gallery, The University
of Manchester
Photograph by www.wearetape.com
Image courtesy the artist

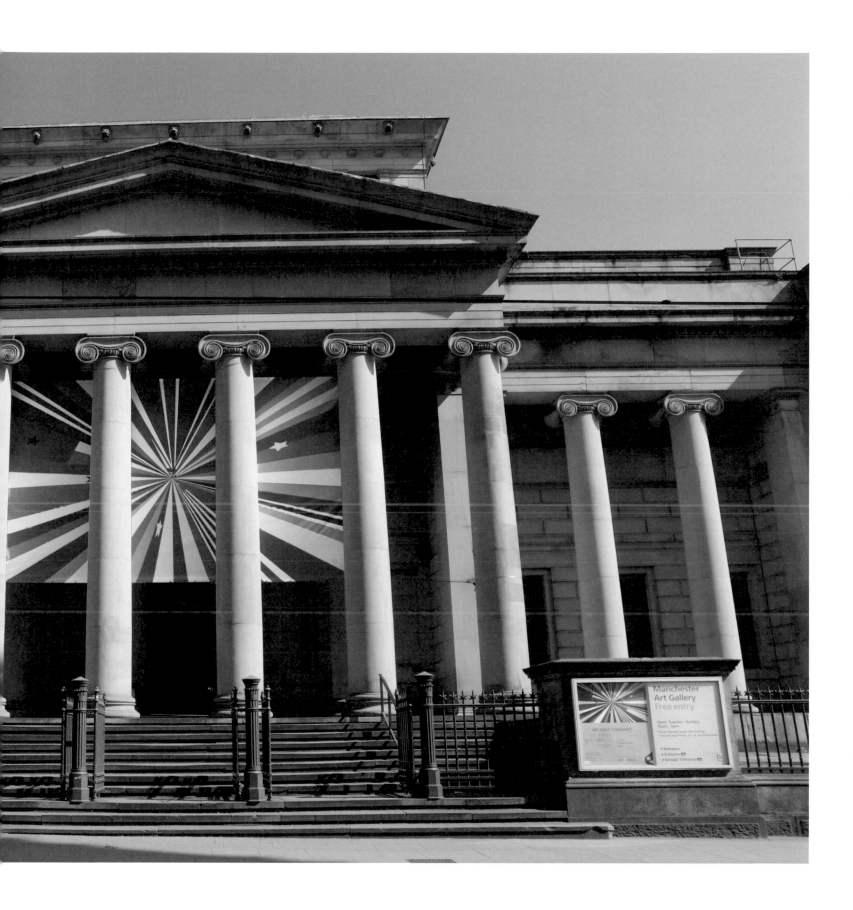

François-Xavier Gbré

Through his seductive photographs of crumbling buildings, François-Xavier Gbré interrogates the architectural evidence of colonial history and highlights what he terms the 'absurdity' that power brings.

Taken from the ongoing series, *Tracks*, the photographs exhibited in *We Face Forward* are not just documents of the forgotten. Many of Gbré's photographs record the moments before, or during, great change. Conducting interviews with people who know the buildings intimately, Gbré traces the changing fortunes of the spaces he photographs.

Buildings in the series include the Modibo Keita swimming pool in Bamako, photographed in 2009 during its renovation by a Chinese company, the Elizabeth Hotel and Theatre in Israel, used by British forces during the Second World War, La Duchère in Lyon, a utopian 1960s housing block principally home to exiles from the Algerian war knocked down in 2010.

Gbré documents the complexities of international politics and the histories written in the stone and concrete he photographs, asking 'which part of history is kept and which part is forgotten?'[1]

..............................

1 Email to Bryony Bond 11 April 2012.

François-Xavier Gbré
Selection from *Tracks* series:
Clockwise from top right:
Elizabeth Theatre I, Tiberias 2009
La Duchère I, Lyon 2010
Swimming Pool VII, Bamako 2009
Photographs
Images courtesy the artist

Romuald Hazoumè

Romuald Hazoumè skilfully employs a wide variety of media in his artworks, including painting, video, photography and sculpture. Using everyday found objects, his fertile imagination combines this diversity to create a striking range of individual sculptures and large-scale installations. As well as being wryly humorous, his work is also deeply serious - even unsettling - deploying his trenchant critiques of imperialism and consumerism to comment upon the ever-changing role of Africa within the contemporary global economy.

Wooden masks were amongst the first items to be exchanged between Africa and the West. Hazoumè's tongue-in-cheek 'African masks,' fashioned from discarded plastic bottles and other found objects, belie their historic and cultural pretensions as traditional ritual objects whilst roundly mocking Western perceptions of African art. Exploiting the brain's hard-wired ability to see faces in objects, each mask becomes a portrait suggesting an actual person or type. Here too Hazoumè underlines a point that is as political as it is environmental, 'I send back to the West that which belongs there, that is to say, the refuse of a consumer society that invades us (in Africa) every day.'

ARTicle 14 displays an actual street-trader's cart from Benin, which would normally carry a range of soft drinks, beer, plastic toys, brushes, footballs, razors, pans, etc. but now displays still-functioning goods that have been thrown away in the West – objects made redundant by technological advance and the constant flooding of the market with 'better' new products. The title refers to the scurrilous rumour that all African constitutions contain a hypothetical final article (ARTicle 14: Débrouille-toi, toi-même.) which translates as 'When all else fails, do what you need to do, because no-one else is looking out for you!' The work reflects on the stark realities of life in Africa today, highlighting the daily struggles of the street vendor, forced to look out for himself by inventing resourceful new strategies to keep himself and his family alive.

Hazoumè's video work *La Roulette Béninoise* depicts the army of Benin's illegal petrol smugglers who ferry contraband petrol between Nigerian sources and their local consumers. Estimates suggest that 90% of all fuel used in Benin passes through these black-market channels. The black plastic jerry cans are heated over flames to expand their carrying capacity, but this also weakens the containers. The overloaded motorbikes transporting contraband fuel are prone to accidents and fatal explosions. Hazoumè first decided to record this footage when he realised that no-one in the West believed that such trafficking was really happening. His poignant documentation sheds a disquieting light on the pervasive exploitation of human labour, which Hazoumè sees as a modern manifestation of slavery still occurring, on our watch, today.

Romuald Hazoumè
Above:

Wax Bandana and *Sénégauloise*
2009

Found objects
Installation at Manchester Art Gallery
Photographs by Michael Pollard
Images courtesy the artist, Robert Devereux
Collection and Private Collection

Right:
*ARTicle 14, Débrouille-toi,
toi-même!* 2005

Multi-media installation
Installation at Whitworth Art Gallery
Photographs by Michael Pollard
Images courtesy the artist and October
Gallery, London

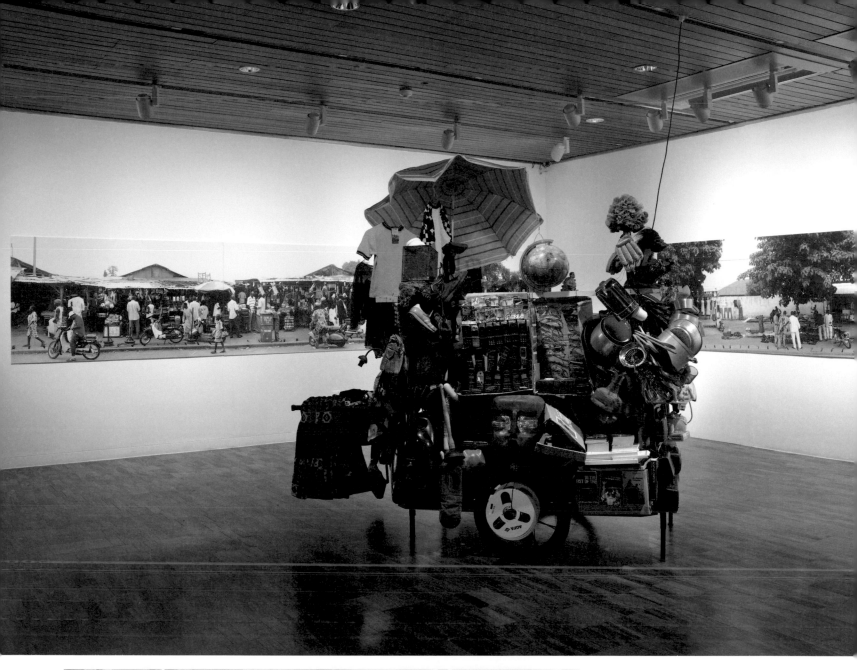

Abdoulaye Armin Kane

..

Abdoulaye Armin Kane is a painter, sculptor and video artist. In his video work, which he develops over long periods of time, he engages with current issues of social, economic, political and cultural life. He has created a signature animation style, each film framed like an analogue TV screen with coloured buttons at the bottom.

On first glance the film *The Event (Yaatal Kaddou/L'Evènement)* 2007 resembles a video game in its use of unnaturalistic colours and graphic representation. Using a static viewpoint of blocks of flats lit up at night, we see and hear the flow of urban life quietly unravelling. The drama which unfolds starts off inside the flats, hidden from our view but we can hear the residents watching a football game as traffic passes outside. Suddenly a power cut disrupts this harmony and there is a clamour of frustration. People leave the building and get into their cars in the now darkened streets. The ensuing accident demonstrates the dramatic consequences of power cuts. Kane does not lay the whole blame on the electricity company but encourages people to take responsibility for their own actions and not to behave dangerously when the lights go out.

In Dakar there can be four or five power cuts every day. The Senegalese Electricity company Senelec 'has been unable to satisfy demand for electricity for years'[1] and there were riots in June 2011 over continuing power shortages. At the end of the film, the sun rises heralding a new day, for it all to begin again.

..............................

1 'Senegal: Buildings toured in powercut riots', www.bbc.co.uk/news/world-africa-13938217, 28 June 2011. [Accessed 23/03/12].

Abdoulaye Armin Kane
The Event (Yaatal Kaddou / L'Evènement) 2007 (stills)
Animation
Images courtesy the artist

Abdoulaye Konaté

When paint and canvas were unavailable to him, Abdoulaye Konaté began using materials native to Mali, namely raw or dyed woven Malian cloth. The large scale textiles of sewn and applied fabric which he creates not only support the local economy but also reference the West African tradition of using textiles to commemorate and communicate. Combining the aesthetics of the local with global subject matter including dictatorships, AIDS, deforestation and the inequalities between north and south, Konaté has created a unique vision in which he merges political commentary and traditional craftsmanship. His response is never one of despair, but of hope, exploring the human condition through thoughtful and critical expression.

Power and Religion (*Pouvoir et Religion*) 2011 is a 7m long textile work which explores the position of Christianity and Islam within political and cultural life. The symbols of religion and government stand out graphically against the grey background which is covered with white spots. The pieces of this fabric recall the plumage of the guinea fowl, a bird imbued with mythical symbolism in sub-Saharan Africa, where it appears in stories, theatre and literature. Malian writer Massa Makan Diabaté, in his book *The Hairdresser of Kouta*, describes how 'the guinea fowl spreads out its colours over its plumage and man keeps them in his heart'.[1] Konaté draws a parallel to the ambiguity that heads of government take towards religion.

1 Iniva Press Release, 16 Nov 2011, available at www.iniva.org/press/2011/ abdoulaye_konate [accessed 1/ May 2012].

Abdoulaye Konaté Right: detail
Power and Religion
(Pouvoir et Religion) 2011
Textile
Commissioned by Iniva (Institute of International Visual Arts), London
Images courtesy the artist and Iniva, London

Hamidou Maiga

Hamidou Maiga first trained as a mason in the Malian city of Timbuktu, but in the 1950s he bought his first camera and began to reinvent himself as a photographer. Maiga opened his first studio in N'Gouma, a small town in central Mali. From here, he would travel along sections of the Niger River, setting up a makeshift studio so that he could make portraits of local people. Maiga returned to Timbuktu in 1960, setting up a new studio, finally moving to Bamako in 1973. It was there that Maiga photographed young people of the city, often showing them dressed in stylish Western clothes against a painted backdrop of a garden, holding transistor radios and other symbols of the success and modernity that the citizens of Mali sought after independence. This style of photography connects with the nineteenth century Western tradition of posing sitters at writing desks and other symbols of social success. It also has its parallel in studio portraits that were made in British industrial towns and cities in the 1960s and 1970s, which depict Black and Asian immigrants with objects such as radios, motorbikes and sunglasses which speak of their success in their new country.

Hamidou Maiga
All images *Untitled* 1973
Gelatin silver prints from original negatives
Images courtesy Jack Bell Gallery, London

Soungalo Malé

Malé's first job was as an assistant to a team of French topographers in the city of San in the South East of Mali. This career came to an end in the 1950s when he discovered photography. Moving to Bamako, Malé initially worked for the great Seydou Keita, before opening the first photography studio in San in 1958. As well as working within this static studio, Malé travelled the countryside with a portable studio and darkroom loaded onto a truck. He would set up a makeshift studio, positioning his sitters sometimes against a wall or a patterned backdrop and take carefully considered portraits, or more candid shots of people at home or work. This movement around the countryside has links with the way in which late 19th and early 20th century photographers in the West would earn a living by travelling to areas where there was no local photographer or to fairs and the seaside, and set up studio for a day or two. Through Malé's adoption of this itinerant practice, we are able to see images of country people at important moments in their lives from the 1950s onwards.

Soungalo Malé
All images *Untitled* 1959 – 1960

Digital prints from original negatives
Images courtesy the artist's estate and
Musée National du Mali

Nii Obodai

The photographs in *From the Edge to the Core* were made during a journey through Ghana taken with Nii Obodai's friend and fellow photographer, Bruno Boudjelal. The content is straightforward – villages, roads and people along the way. But the way in which Nii Obodai deals with these scenes through the lens of his camera is full of poetic and spiritual meaning. The artist balances images, precariously, at the edge of focus, on the verge of slipping away from being figured. He allows the light, and the dark, to fill the small closed room of his camera and make intense flares and shadows upon his film and prints. In doing this, a child becomes of the beach rather than on it; a man's head dematerializes; a road is effulgent with the light of the sun.

Nii Obodai's intentions in this project, as an artist, is to create a visual relationship between the land, the culture of Ghana and the question of being. His father was a close friend and aide of the country's first President, Kwame Nkrumah, and the ideology of that struggle for independence from Britain in the 1950s is evident in Nii Obodai's intent – the artist avoiding identifying tribal affinities or locations in a desire to represent one Ghana and one authentic self.

Nii Obodai
Above and left:
1966 2009

Right:
The Passing 2009
Digital prints
Images courtesy the artist and
Institut Français

Emeka Ogboh

..

Lagos Soundscapes is an ongoing project by Emeka Ogboh, capturing the ever-changing sounds of Africa's most populous city and his own hometown, Lagos, Nigeria. Described by Ogboh as a city shaped by globalisation, a 'mélange of new and old, modern and archaic, first and third world'[1], Lagos' distinctive personality is embodied in the sound of its streets.

In Manchester Ogboh has chosen to locate the atmosphere of a market in Whitworth Park and bring the sounds of Lagos' famous bus parks to the street outside Manchester Art Gallery and Piccadilly Gardens. Unobtrusively installed, the sound is encountered without prior warning, Ogboh seeks to prompt a split-second sensation of dislocation, transporting the listener thousands of miles in an instant.

Initially interested in how these soundscapes would be encountered and responded to by non-Lagosian audiences, as an expression of the exotic, Ogboh has also become increasingly interested in reaching the Nigerian disapora, like the large community living in Manchester and creating moments of reconnection with the familiar.

Exploring the imaginative possibilities of a distinctive sound, Ogboh's *Lagos Soundscapes* also interrogate issues of migration, displacement and the homogenising forces of globalisation.

..............................

1 Emeka Ogboh from
 http://www.14thmay.com/about.html
 [accessed 2/5/2012].

Emeka Ogboh
Clockwise from top right:
Mic and the City, Ojuelegba 2012
PA System, Obalende 2012
Photographs by Emeka Ogboh

Lagos Soundscape (LOS – MAN)
2012

Amplified sound
Installation at Whitworth Park
Photograph by Michael Pollard
Images courtesy the artist

Abraham Oghobase

...

Combining photography and performance, Abraham Oghobase investigates the purpose of existence by attempting to capture a wide range of human emotions through photography. Loneliness, fear, anxiety, solitude and freedom are some of the feelings he explores using his own body as subject matter. He aims to de-construct and even to de-contextualize in order to find a new, unique meaning for the individual who continuously has to negotiate his way through the world to find his place on this planet.

Oghobase's secondary subject is the city and the relationship of the individual to the urban landscape. His home of Lagos is a metropolis of over ten million people and the commercial capital of Nigeria. Competition for space is a daily struggle and every available wall is indiscriminately plastered with hundreds of handbills and posters, scrawled with text advertising the many and diverse services offered by the city's enterprising residents. His new series *Untitled* (2012) shows the artist's body positioned in relation to one such graffitied wall, a site which was formerly a commercial area for shops. Oghobase is interested in how we consume and the way people have utilised the landscape to sell their goods and services. He remarks that 'validating the authenticity of the information contained in these ads becomes quite a complex task for the consumer due to the disorganised mode of presentation and often incomplete details. My engagement with one such wall of "classifieds" serves to question the effectiveness of such guerilla marketing.'[1]

..........................

1 Abraham Oghobase in an email to the Natasha Howes 26 January 2012.

Abraham Oghobase
Clockwise from top right:
Untitled 2012
Untitled 2012
Untitled 2012
Installation at Manchester Art Gallery
Photograph by Michael Pollard

Digital prints on aluminium
Images courtesy the artist

Amarachi Okafor

···

Amarachi Okafor is interested in the process of transformation and the concept of use, history and memory embedded within a material. Inspired by everyday things which we often overlook like plastic bags, letters or rubbish bags, she carefully selects materials not only for their texture but also for their socio-economic context and connotations of use. Her work engages with diverse issues including human relationships, culture, religion, history, gender and sexuality. Okafor uses sewing to create her artworks not only due to an interest in fashion and referencing women in her local community, but also as a cathartic process of mending broken material.

The Shape of Hanging Skin 2009, a curtain made from the discarded scraps of synthetic leather from the shoe factory, Dale Sko, in Norway, is a work which speaks to both individuals and wider society. The work originates as the curtain on Okafor's studio door, thus signalling the boundaries of 'a place where I take refuge. It is my fortress. But it is also my playground, as well as the place where I feel in control'[1]. Taken out of this context, the curtain becomes symbolic of society's acceptance of systemic corruption – constantly pushed against, always accepting. It is these parallel and competing meanings that confront us as we take our place amongst the people who brush past this ever-yielding fake leather. Yet in January 2012, the Occupy Nigeria protests over petrol prices reminds us that a population will not necessarily always yield.

·····························

1 Amarachi Okafor in an email to Natasha Howes 17 November 2011.

Amarachi Okafor
The Shape of Hanging Skin 2009
Synthetic leather off-cuts
Installation at Manchester Art Gallery
Photograph by Michael Pollard
Images courtesy the artist

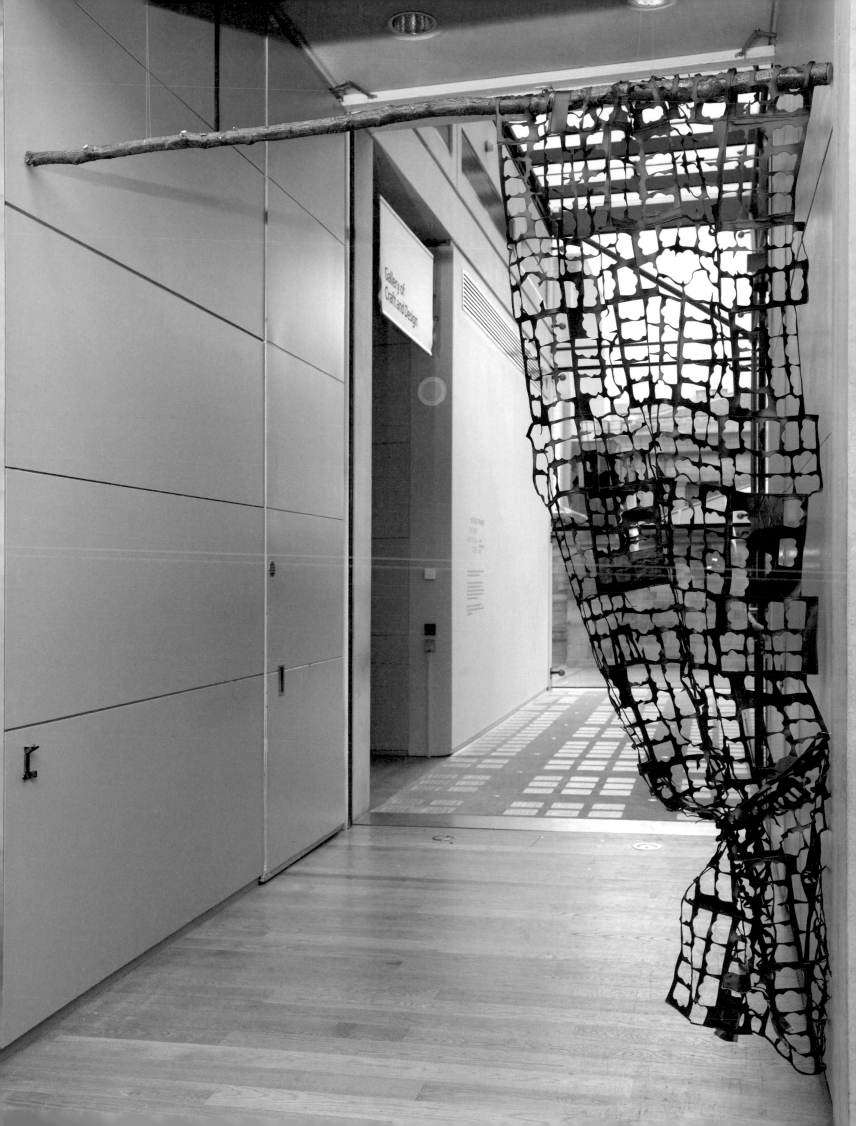

Charles Okereke

...

Begun in 2009, Charles Okereke's series *The Canal People* documents the Festac village settlement in Lagos state, Nigeria, a stretch of stilt houses built along the Festac canal offering cheap accommodation for the poorest in society.

The series contains many 'sub-chapters', each focusing on distinct subjects such as architecture, daily life and style. The photographs exhibited in *We Face Forward* are selected from the chapter concerning the environment. For this section, Okereke chose a deliberate style of photography, setting out to simulate the techniques of advertising. 'For products to be attractive the images must glamorise, so ironically I was doing the same.'[1] Okereke's luxurious close-ups and super-saturated colours turn the oily, polluted canal into a sparkling night sky; waste suspended in the canal's reflective surface is beautifully composed, like an elegant still-life.

Once in a Blue World captures Okereke's own reflected image, showing the photographer himself at work, demonstrating the artifice, whilst also raising issues of the environment and the global threat of pollution.

Okereke's work highlights photography's capacity to abstract and to politicise. Through his lens the most polluted of subjects is rendered beautiful, and the microcosm of one canal can be read as a universal concern.

...............................

1 Charles Okereke in an email to Bryony Bond 11 April 2012.

Charles Okereke
Selection form *The Canal People* series 2009-10
Clockwise from top right:
Fuelled Tank
Red Peeping Mermaid
Once in a Blue World
Photographs
Images courtesy the artist

Nnenna Okore

I desire to heighten ... the perception of textures, undulating contours and movements that exist within our ephemeral world.[1] Nnenna Okore

Nnenna Okore uses ordinary materials to create extraordinary sculptures. Taking biodegradable material such as old newspapers, rope, thread, yarn, burlap, dye, coffee, starch and clay she transforms them into dazzling abstract forms. Her methods include fraying, tearing, teasing, weaving, dying, waxing and sewing; repetitive processes which she learned by watching local Nigerians perform daily tasks. These labour-intensive methods transform her materials into new forms with an emphasis on delicate surfaces, new textures and visceral materiality. She is inspired by nature and how organic matter becomes weathered, dilapidated and lifeless, signalling wider concepts of aging, death and decay. Her interest in recycling and finding value in discarded material prompted Nigerian journalist Uzor Maxim Uzoatu to say of her work, 'Life throbs in all disused matter.'[2]

When the Heavens Meet the Earth is a large-scale installation made from hessian, acrylic and dye. Seemingly floating in front of the wall, it is partly fixed to the wall and partly suspended from the ceiling. Some parts are twisted into thick, heavy forms, other parts look like a thin translucent gauze. Its reference points cannot be pinned down; the dark colour of the work seems resonant of the earth and landscape but its lightness and ethereality is evocative of clouds in the sky. The interplay of shadows on the wall behind is as much a part of the work as the solid form itself; the whole becoming a dynamic elegy on immateriality.

..............................

1 Artist Statement www.nnennaokore. com/Statement.html [accessed 17 May 2012].
2 Uzor Maxim Uzoatu 2009 Wakeful Souls, 234next.com (online). Available at http://234next.com/csp/cms/sites/Next/ ArtsandCulture/5430387-147/story.csp [Accessed 14 November 2011].

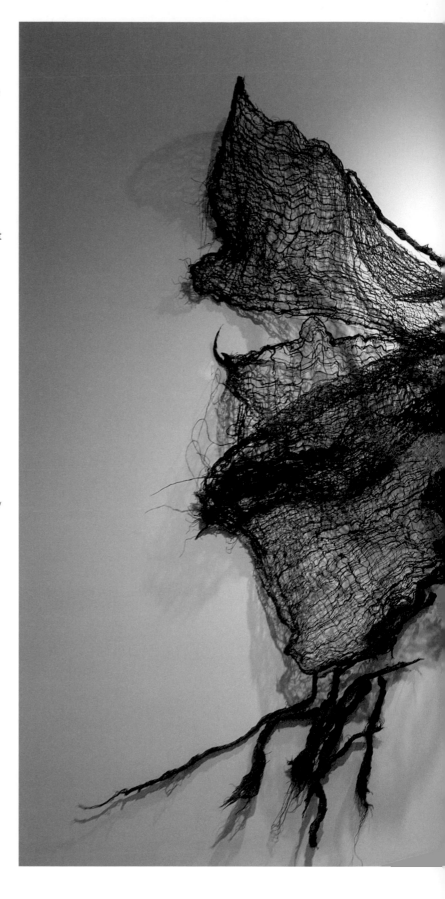

Nnenna Okore
When the Heavens Meet the Earth
2011
Burlap, dye and acrylic
Image courtesy the artist and
Robert Devereux Collection

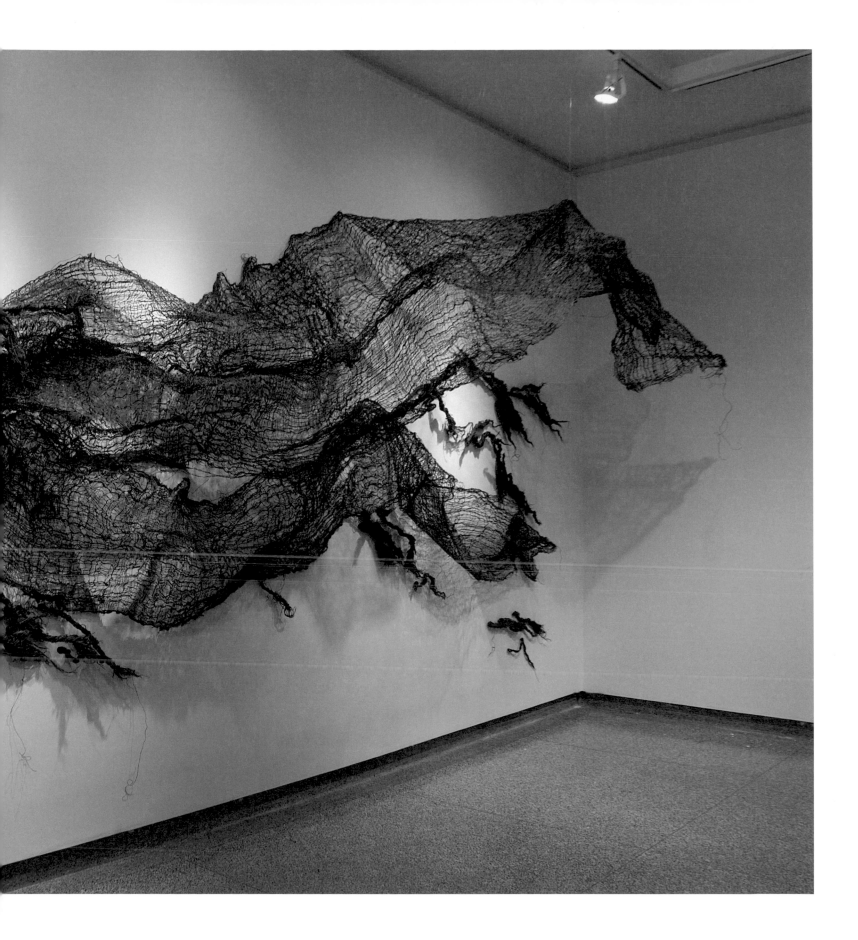

Duro Olowu

..

'My work, like my eye, is certainly international in its aesthetic, offbeat yet focused. As such, I am always open to the surprise of the new, the technique and skill of the past and the ability of fashion and art to challenge preconceived ideas of taste and culture.'[1]

Born in 1965 in Lagos, Nigeria to a Nigerian Father and Jamaican mother, Olowu spent his childhood travelling between Nigeria and Europe. From an early age, his enthusiasm for fashion was inspired by the unexpected mix of fabrics, textures and draping techniques of the clothing worn by the women that surrounded him. Like his father before him, he trained as a lawyer but later turned to a career in fashion, launching his label in 2004. His first collection was an instant success and featured the now signature 'Duro dress' hailed by both British and American Vogue as the dress of the year in 2005. That same year the British Fashion Council honoured him with the prestigious New Designer of the Year Award at the British fashion awards. In 2010 he won the Best Designer Award at the African Fashion Awards 2010 in South Africa and was a also finalist for the Swiss Textiles Award in Zurich.

Alluring silhouettes, sharp tailoring, original prints and luxurious vintage textiles in off- beat, yet harmonious combinations, are Olowu's signature, inspired by his Nigerian and Jamaican heritage. He has shown as part of New York Fashion Week since 2011. Olowu is inspired by a wide range of music, and is also particularly interested in fine art, naming artists such as Glenn Ligon, Cindy Sherman and David Hammons as favourites.

His Autumn/Winter 2012 collection centred around a self-portrait by Egon Schiele and he describes the effect as being like a beautiful jigsaw puzzle.

..

1 Duro Olowu quoted in the press release for *Material: A group show curated by Duro Olowu*, Salon 94 Freemans, New York, USA, 8 February to 31 March 2012.

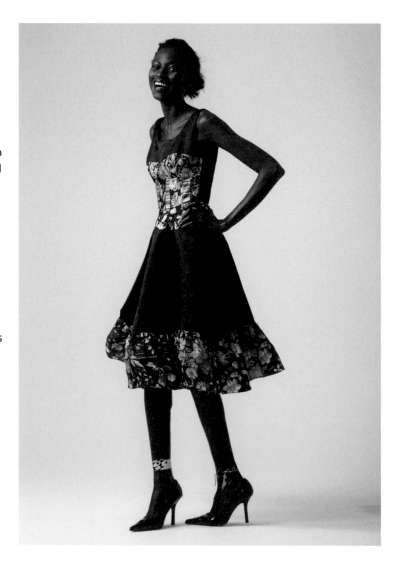

Duro Olowu
Spring / Summer Collection 2012

Photographs by Robert Fairer
Images courtesy the designer

George Osodi

The Niger delta region is of fundamental importance to those in power in Nigeria as the oil from that region makes up 95% of the country's export trade. Between 2003 and 2007, George Osodi documented this area and the dramatic effect oil mining had on the landscape and local population. *Oil Rich Niger Delta* contains over 200 visually arresting and hard-hitting photographs depicting the degradation of the eco-system and human labour by multi-national oil companies. Osodi has said that when 'oil becomes a commodity, an incredible visual drama unfolds.'[1] We are presented with images of poverty, corruption and violence which reflect the urgency of the situation.

Osodi employs classical photographic motifs to great effect. Close-up portraits, landscapes taken with a wide-angled lens and portraits with dramatic foregrounds or backgrounds, often with fire or black clouds of smoke. There are scenes with camouflaged and heavily armed MEND militants (Movement for the Emancipation of the Niger Delta who demand a share of the oil money) in which the ammunition creates striking visual surface patterns and other photographs exploiting seductive reflections in water.

The population does not benefit from the huge amount of wealth created in their locale. We see men, women and children going about their daily lives in their polluted and ravaged landscape. Osodi reflects that 'people are of great value to me, especially what I call the real people. They are a source of joy and inspiration to me. In recent times, the impact of oil in the lives of most oil producing regions has been highly paradoxical...I want to put a human face on this paradise lost.'[2]

1 www.goethe.de/climate
2 George Osodi quoted in *Pale Reflections and Fables of Life: George Osodi's 'Real People' of the Niger Delta*, Raw Material Company, 2011.

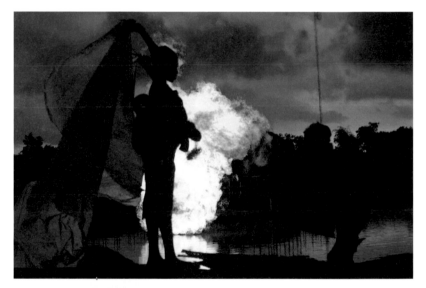

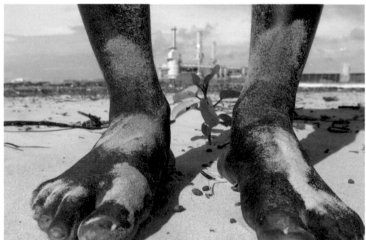

George Osodi
All images *Oil Rich Niger Delta*
2003 – 2007

Photographs
Images courtesy the artist and
Z Photographic Ltd

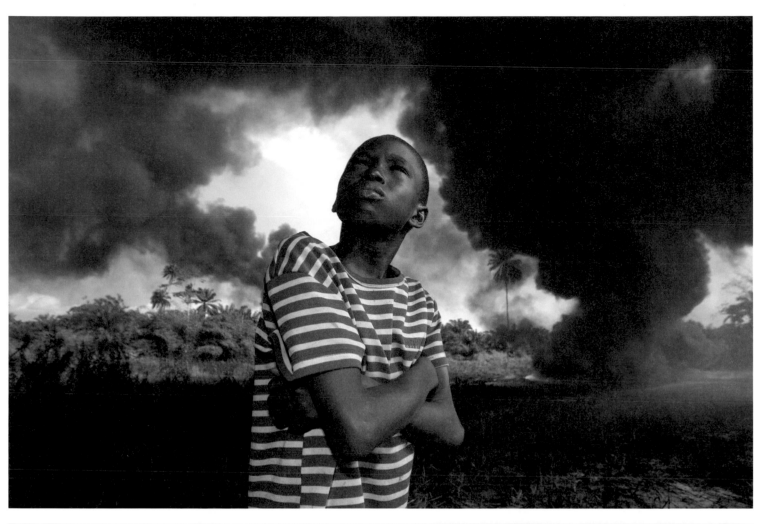

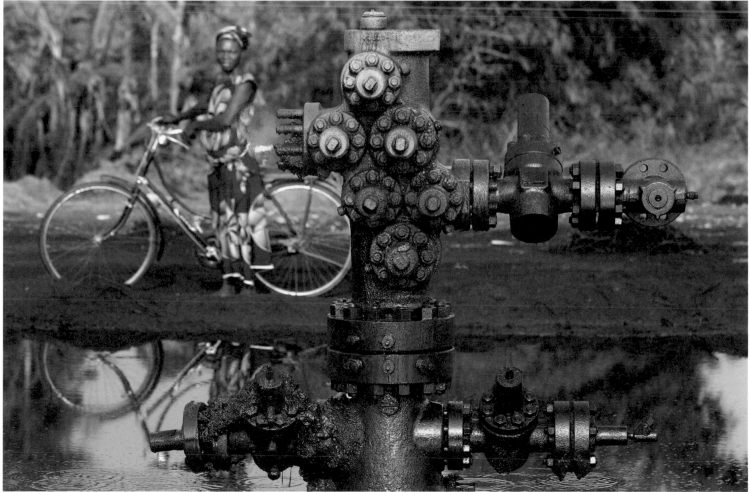

Nyaba Léon Ouedraogo

From dawn to dusk, dozens of young Ghanians, from 10 to 25 years of age, exhaust themselves seven days a week. Their mission is to disassemble the old computers and burn certain plastic or rubber components to cull the precious copper, which will then be resold. Everything is done by hand or with iron bars, makeshift tools found among the refuse. They have neither masks nor gloves. There are not even any functioning toilets,[1]
Nyaba Léon Ouedraogo

The photographic series *The Hell of Copper* documents the 10 square kilometre electronic graveyard of the Aglobloshie Market in Accra, Ghana where thousands of computers and electronic goods are shipped from Europe and North America. Children and young people dismantle old computers and burn the plastic or rubber components to reveal the valuable copper. This metal is then resold to Nigerians or Indians who rework it to make mostly jewellery that is sold cheaply in Europe. This economy of waste has dramatic consequences for the environment and the health of the workers who handle them.

Using their bare hands, the young workers are exposed to lead, mercury, cadmium and PVC plastic which are incredibly toxic to the human body. These chemicals have seeped into the nearby canal and also contaminate the grazing land for cows and sheep. Ouedraogo's imagery of the sprawling landscape filled with computer carcasses and the individuals engaged in this dangerous work demonstrate the profoundly troubling consequence of the constant search for the latest phone, fastest computer or new electronic gadget.

...............................

1 www.prixpictet.com/2010/ statement/1327 [accessed 17 May 2012].

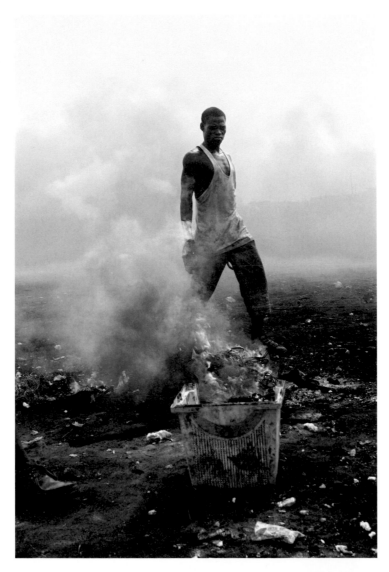

Nyaba Léon Ouedraogo
All images *The Hell of Copper (L'Enfer du Cuivre)* 2008
Photographs
Images courtesy the artist

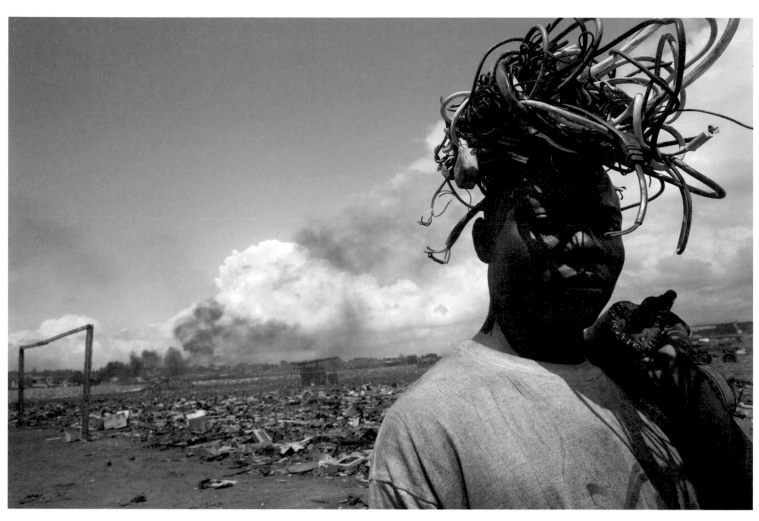

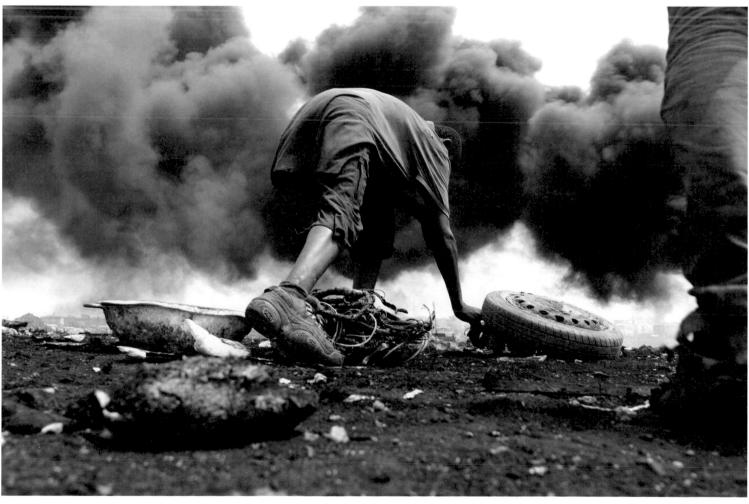

Piniang

Piniang (Ibrahima Niang) is a painter, video maker and sculptor whose artistic process is based on using a fusion of materials. Once he began working in animation, this influenced his painting style. A theme throughout his work is the evolution of man and his environment, dealing with all aspects of daily life and making work about issues which affect the community.

The paintings *Flood in the Suburb 1* and *2* and *Power Cut in the Suburb* relate to the ongoing problem of power shortages in Dakar, Senegal. On first glance his canvases look like abstract compositions. However they are depictions of the architecture of Dakar plunged into darkness during one of the many power cuts. This urban chaos with its lack of planning regulations, houses built on top of each other and dangerously over-laden electricity and telephone cables affects large numbers of people. Piniang said 'Everybody sets up homes wherever. People build in their own style, without asking anyone. If a family gets larger, they increase their home.'[1]

An additional problem is that the government is trying to modernise and wants to build large, prestigious buildings instead of concentrating on basic services like food, water, health, education and transport. Collaged onto the paintings are headlines and quotations from newspapers; 'Bla bla bla' suggests the noise levels in the overcrowded accommodation and 'la Senelec Saccagée' refers to the sacking of the main Senegalese electricity company. The paintings have a metaphorical as well as literal darkness too, in that Piniang sees no solution to these problems – the issues will get worse as the population increases and he advocates that the politicians start to plan for these long term implications rather than just thinking about their next election victory.

..............................

1 Piniang quoted in 'Piniang s'engage dans les rues du Dakar banlieue' le Ouest France, 4 April 2011.

Piniang
Clockwise from top right:
*Flood in the Suburb 1
(Inondation en Banlieue 1)* 2011
Power Cut in the Suburb (Delestage en Banlieue) (detail) 2011
*Flood in the Suburb 2
(Inondation en Banlieue 2)* 2011
Newspaper collage, acrylic and pigment on canvas
Images courtesy the artist

Nyani Quarmyne

In the area of Ghana where the Volta River empties into the South Atlantic, a long spit of land is being eroded. In the 20th century sea levels rose worldwide by 17cm and this, coupled with seasonal storms that pound the coastline, means that people's homes are being lost to sand and water. Nyani Quarmyne has photographed several villages near the small town of Ada Foah. He shows us some of the people in the ruins of their houses, which many cannot leave as they have nowhere else to go. Quarmyne makes a point of telling us their names, Numour Puplampo and Vincent Tetteh Teye and others, and meets their eyes through his camera.

Quarmyne began to make photographs in 2008 and since then has gained a strong reputation as a documentary photographer, working for many agencies and publications. In the way he works with his subjects over many months and his desire to tell us the whole story, Quarmyne's work resonates with the Western traditions of documentary photography. His photographs, however, are of West African people with whom he has a cultural and social affinity and whose stories he himself is implicated in.

Nyani Quarmyne
Selection from *We Were Once Three Miles from the Sea* series 2010 – 2011:
Clockwise from top right:

We Were Once Three Miles from the Sea

A Beach in my Living Room

Collins in a Window

Photographs
Images courtesy the artist

Raw Material Company

Established in 2008 by independent exhibition maker and cultural producer Koyo Kouoh, Raw Material Company (RMC) is a centre for art, knowledge and society in Dakar, Senegal. Comprising a resource centre, exhibition space, residential facility and rooftop bar restaurant, RMC is based on the firm belief in visual arts as a potent tool capable of shifting views and igniting engagement in art practice as a viable path for social and political transformation. During *We Face Forward* an outpost of RMC has been established at the Whitworth Art Gallery, which contains elements of all the institutional formats supported in Dakar.

A central facet of RMC is the resource centre, a growing library of publications and periodicals on contemporary art with a particular emphasis on African and Africa-related practices. The resource centre regularly hosts discursive events; from artist talks and master classes, to discussions and portfolio critiques. In Manchester, the RMC space will screen films of events and talks from Dakar, and will itself host a series of talks, screenings and other events every Saturday afternoon throughout the exhibition.

At home, RMC's exhibition programme brings international artists to Senegal and shows works by Dakar-based artists, striving to foster appreciation and a growth of artistic and intellectual creativity in Africa. In Manchester, RMC shows selected works by Mansour Ciss Kanakassy and Otobong Nkanga, taken from previous exhibitions at RMC.

The Afro created by Kanakassy is an imaginary currency that is a 'materialization of hope', Kanakassy calls 'upon everyone's good will and awareness for a united, emancipated and developed Africa. We are hoping to create emotion and start a momentum at policy level around new African awareness.' The exhibited works by Otobong Nkanaga are selected from her series *The Taste of a Stone*, shown in *Make Yourself at Home (Faites Comme Chez Vous)* which looked at how artists interpret ideas of home and hospitality in a globalised world.

Finally, RMC's roof top bar and restaurant is transplanted to The Modern Caterer at the Whitworth, which, over the summer, will produce a Senegalese-inspired menu.

Raw Material Company, Dakar, Senegal
Images courtesy Raw Material Company

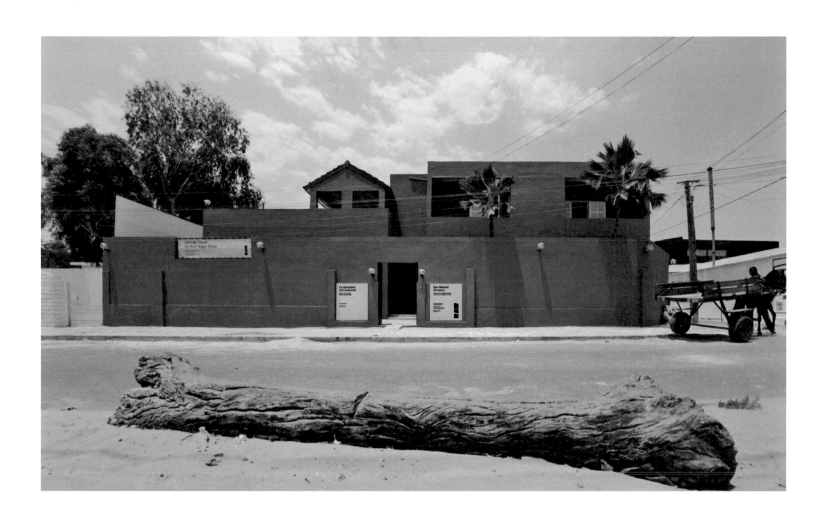

Abderramane Sakaly

As a young man Sakaly learnt photography at an established studio in Saint Louis, Senegal. Moving to Mali's capital, Bamako, in 1956, he set up his own studio and began to specialize in photographing the social circles of military officers and the growing middle class. After Mali's independence and with the subsequent growth of the bureaucratic class, his studio became very successful. Just before he died in 1988, Sakaly was named the first President of Groupement National des Photographes du Mali.

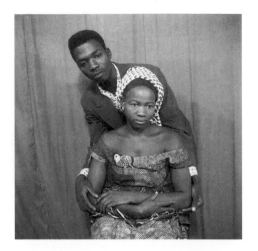

Abderramane Sakaly
All images *Untitled*, Mali 1958

Photographs
Images courtesy the artist's estate and the
Musée National du Mali

Amadou Sanogo

It is important that Amadou Sanogo's paintings have no frames. He makes his canvases from lengths of workaday cloth bought in the local market, choosing not to stretch them or present them within the enclosure of a frame. This conscious distancing of his work from the Western conventions of painting speaks of his desire to identify those points of difference and similarity between the past and the present, traditional and contemporary culture, and the role of young people within this culture. The subject matter of his paintings scrutinises national and international politics, journalism and the justice system. Sanogo follows the news closely on TV5 Monde, online and in the press, and gathers images of presidents, newsreaders, and other public figures who have been corrupted by power, rendering them in powerfully expressive paint. This method of seeking his subject matter through television stems back to his earliest experience of drawing outside a television shop in his home town of Ségou, Mali.

Amadou Sanogo
Clockwise from top right:
Journalists' World (Le Monde Journalistique) 2011
The Disabled Gaze (Le Regard Handicappé) 2011
The Jury (Le Juré) 2011
Acrylic on fabric
Images courtesy the artist

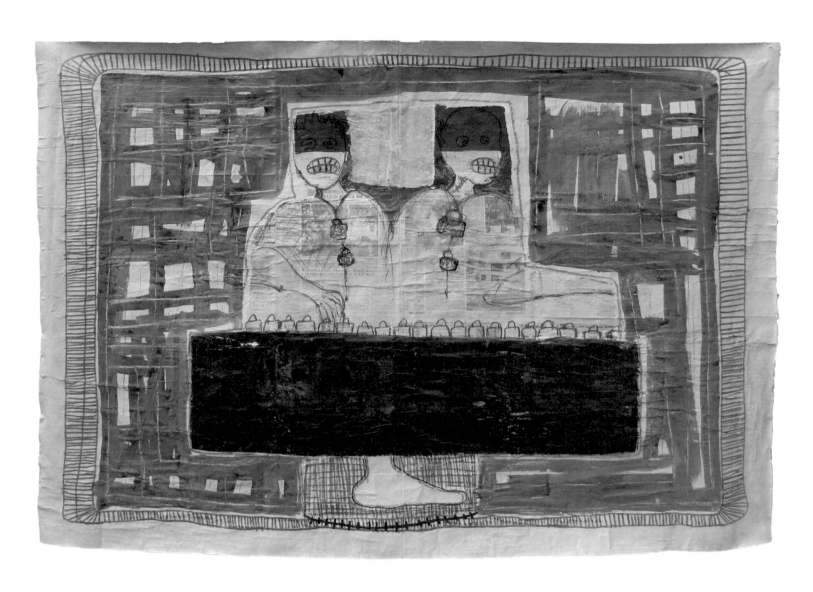

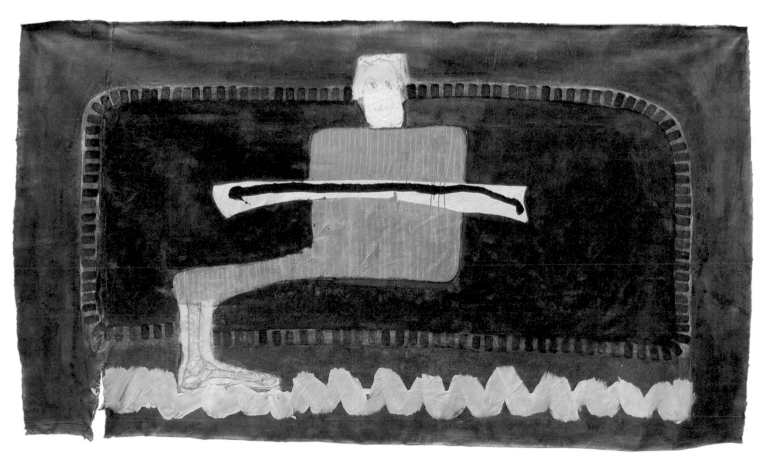

Malick Sidibé

After Mali achieved independence from France in 1960, its capital, Bamako, underwent great cultural changes. Suddenly, everything seemed possible. The country was reborn, outward looking and confident about the future. The young people of the city celebrated these new and exciting times with parties that stretched through the night. Malick Sidibé was perfectly placed to capture this time in photographs. He would be invited to these parties, three or four a night, and with his small twin-lens reflex camera would photograph the young people dancing and posing. Before dawn, the film would be processed and printed, and then pinned up outside his studio ready for the party-goers to spot themselves and possibly buy the print.

Sidibé had learnt photography whilst working for Bamako's society photographer, Gérard Guillat. Unlike most white photographers, 'Gégé la pellicule' allowed his young studio assistant to buy a camera. Guillat would photograph the Europeans, and Sidibé the Africans. Sidibé went on to revolutionise studio portraiture, incorporating a lightness of touch and informality that sought to capture the vivacity of his sitters. Best clothes were worn, Vespas ridden, and transistor radios held by Malians who put their faith in Sidibé's ability to represent them in the way that they wished to be seen.

Malick Sidibé
All images *Untitled* 1963 – 1976

Photographs
Images courtesy the artist and the Musée National du Mali

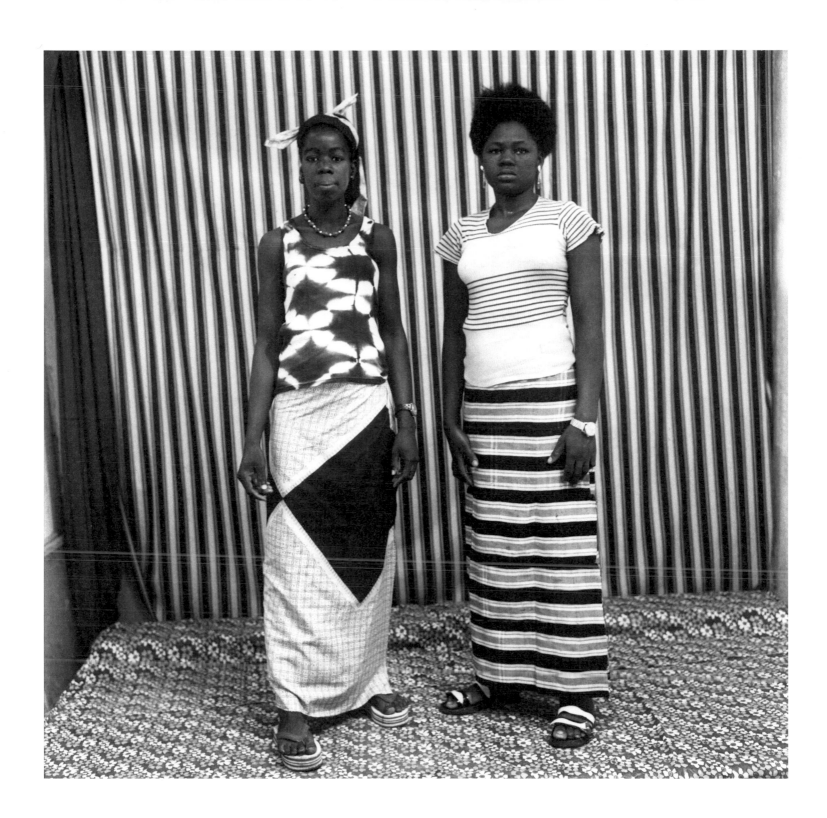

Pascale Marthine Tayou

Pascale Marthine Tayou's installations are places where imagination, history, economics and spirituality co-exist, in his words creating "a bridge between thinking and dreaming."[1]

The World Falls Apart, Tayou's new work created for this exhibition and shown at the Whitworth, is an interior forest that spills out into the neighbouring park. Taking inspiration from one of the most widely-read novels in African literature, *Things Fall Apart* by Chinua Achibe, Tayou's installation is a "cultural traffic jam"[2]. African sculptures made for the tourist market peer down from wooden poles, steel diamonds hang from chains and translucent forms stuffed with discarded food packaging and crowned with wigs are suspended overhead. The distinction between trade goods and sacred objects is blurred, the diamonds look like objects of veneration as much as symbols of Africa's plundered material wealth. Cultural definitions are indistinct and impossible, the trees are squared and unnatural, and the forest is haunted by numbers and chains.

At Manchester Art Gallery, Tayou's *Poupées Pascale* and *Les Sauveteurs Gnang Gnang (Femelle + Mâle)* populate the ledges of neo-classical architecture and the historic galleries of Victorian art. Playing with conceptions of African art, the figures are also Tayou's own exploration of the enduring fascination and power that fetishes possess: "[C]arving masks and statues in crystal is my last chance to see into the 'mystery of Fetishes', but I have been waiting to do that ever since my first sculpture. I can't penetrate the African mask which, in spite of my efforts, seems endlessly unfathomable."[3]

The 'dolls' are also embroiled in global everyday life, festooned and occasionally smothered with what Tayou has described as "contemporary objects taken from the modern fetishism"[4]. They are adorned with cable ties, key rings, plastic bags, brightly-coloured beads, brushes and plastic knives; the ubiquitous and omnipresent products of gift shops, thrift stores and airports the world over.

Tayou's weightless combinations of the spiritual and the prosaic, the serious and the comical are analogous to the daily experience of lived life. "I always see my exhibitions as a mixture of salt and sugar. It's life. You're always happy and then sad afterwards, and it starts again and there's harmony – a bit of light and a bit of darkness."[5]

..............................

1 Pascale Marthine Tayou in conversation with Bryony Bond April 2012.

2 Ibid.

3 Pascale Marthine Tayou as quoted in *Always All Ways* 24/02 – 15/5/2011 Press Release, Musée d'Art Contemporain de Lyon.

4 Pascale Marthine Tayou as quoted in *Pascale Marthine Tayou: Le Grand Sorcier de Utopie*, Gli Ori, 2009, p. 187.

5 Pascale Marthine Tayou as quoted in *Always All Ways* 24/02 – 15/5/2011 Press Release, Musée d'Art Contemporain de Lyon.

Top right:
Pascale Marthine Tayou
*Les Sauveteurs Gnang Gnang
(Femelle + Mâle)* 2011
Crystal, mixed media, wood, cowrie, tissue
Installation at Manchester Art Gallery

Bottom right and above:
Poupées Pascale 2010 – 2012
Crystal, mixed media
Installation at Manchester Art Gallery
Photographs by Michael Pollard
All images courtesy the artist and Galleria
Continua, San Gimignano / Beijing / Le Moulin

Following spread:
*The World Falls Apart
(Le monde s'effondre)* 2012
Mixed media
Installation at Whitworth Art Gallery
Photograph by Michael Pollard
Image courtesy the artist and Galleria
Continua, San Gimignano / Beijing / Le Moulin

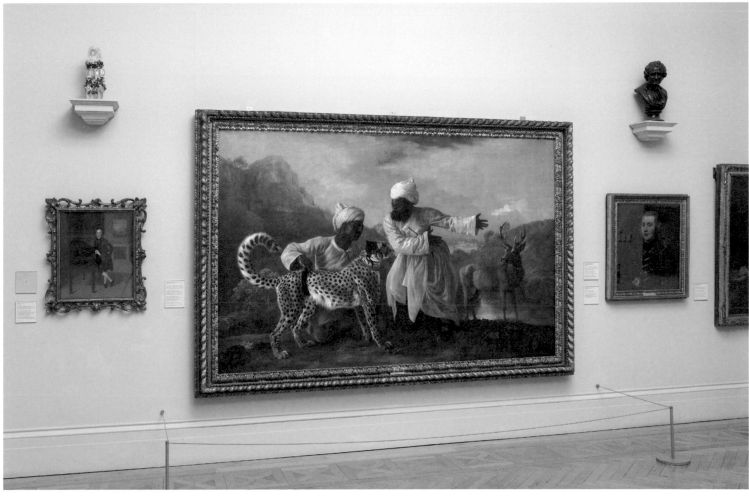

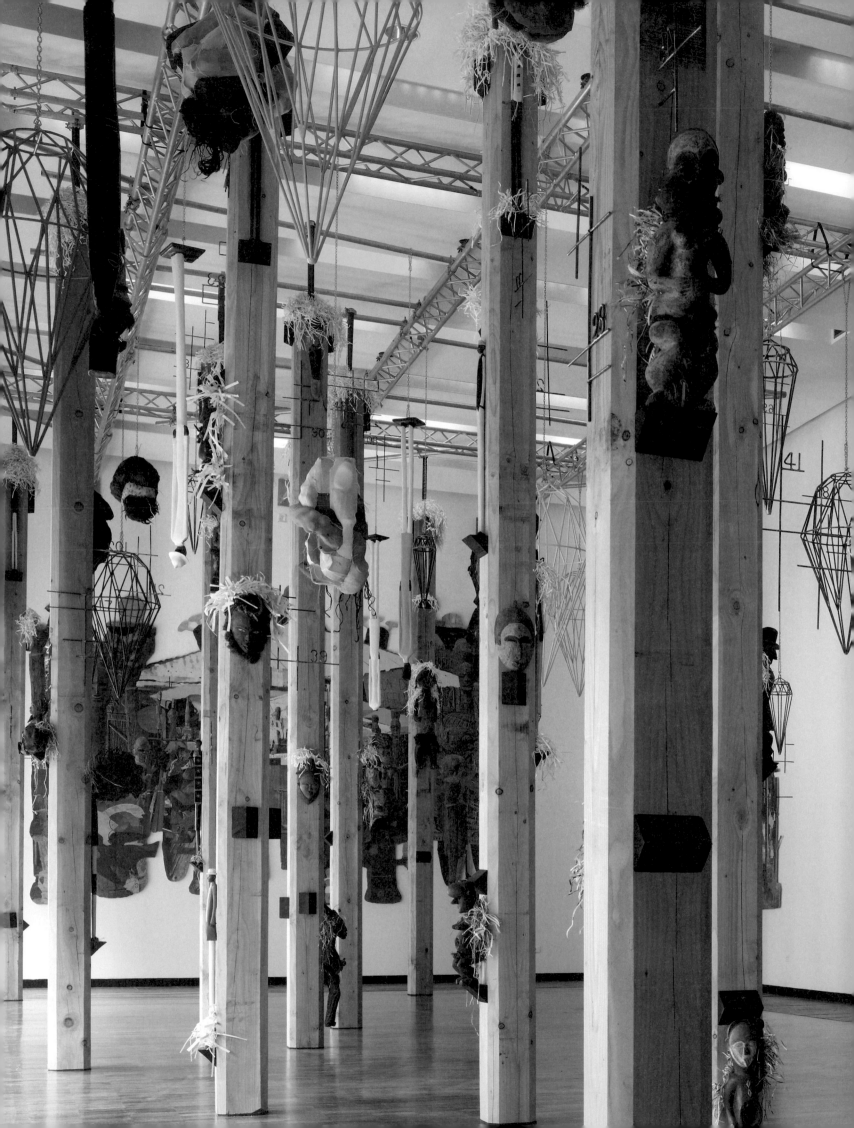

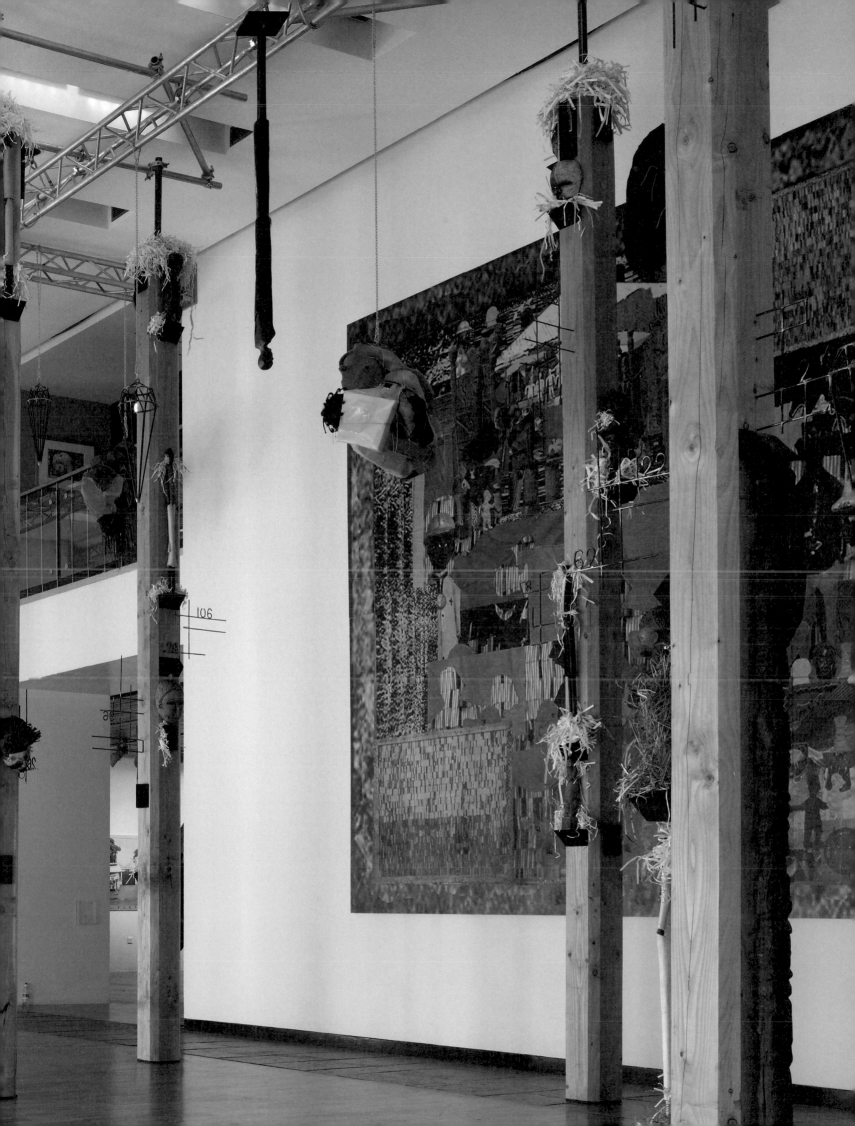

Barthélémy Toguo

In a globalised world where, for some at least, travel and movement is easy, Barthélémy Toguo exposes the absurdities of borders and boundaries and explores the effect travel and transition have on an individual's sense of identity, freedom and human relationships and emotions. The West was happy to take raw materials from the African continent and developing countries but when it comes to the movement of people today, many controls remain in place. Despite the serious content, Toguo provokes and disarms us using black humour, theatre and fantasy.

Employing sculpture, installation, performance, photography and film, drawings and watercolours, Toguo's versatility is astonishing. The artist has held a fascination for wood since his childhood in Cameroon when he witnessed large logs being traded at the marketplace. Rather than referencing an African tradition, he sculpts with a chainsaw allowing him to work quickly with unexpected results. In contrast to the solidity of wood, Toguo's watercolours have a subtlety and lyricism as the paint oozes, seeps and dissolves onto the paper. This technical poetry belies the often violent imagery as human and animal limbs and body parts float in space, connected by a flow of liquid which ultimately and very simply express 'life'. His new site-specific large watercolour for the Whitworth, *Purification*, is based on an interpretation of the sufferings experienced by various populations through deportations and genocides of the last century.

Towering above visitors to Manchester Art Gallery stand two monumental wooden chairs, each 5m high, representing the meeting between North and South. Carved onto the large border control stamps are the words Liberty, Republic of Love, Giving Person, Peace, No War, Hospitality – these are the dreams of those migrating with their bags and belongings to a promised land – ironic in face of the reality they will encounter. Nearby sit three wooden suitcases, a replica of Toguo's 1996 performance *Transit 1*, which dumbfounded Parisian airport customs officials who were used to gleefully searching his luggage.

Redemption 2012 is inspired by Bob Marley's final concert in Pittsburgh in September 1980 in which he sang *Redemption Song* whilst ill with terminal cancer. Toguo says 'My installation is a call to freedom and salvation of people ... man must redeem himself, purify himself from all blame to recreate a fraternal alliance. A new generosity must be born in our contemporary society in order to prevent the suffering of oppressed people in exile such as the Roma. Man must banish evil, celebrate generosity and therefore find redemption.'[1]

1 Barthélémy Toguo in an email to Natasha Howes 25 April 2012.

Above:
Performance by Barthélémy Toguo
1 June 2012
Photograph by Alan Seabright

Right:
Barthélémy Toguo 2012
Redemption 2012
Mixed media
Installation at Manchester Art Gallery
Photograph by Michael Pollard
All images courtesy the artist, Bandjoun
Station, Cameroon and Galerie Lelong, Paris

Following spread:
Purification 2012
Watercolour on paper
Photograph by Michael Pollard
Image courtesy the artist, Bandjoun Station,
Cameroon and Galerie Lelong, Paris

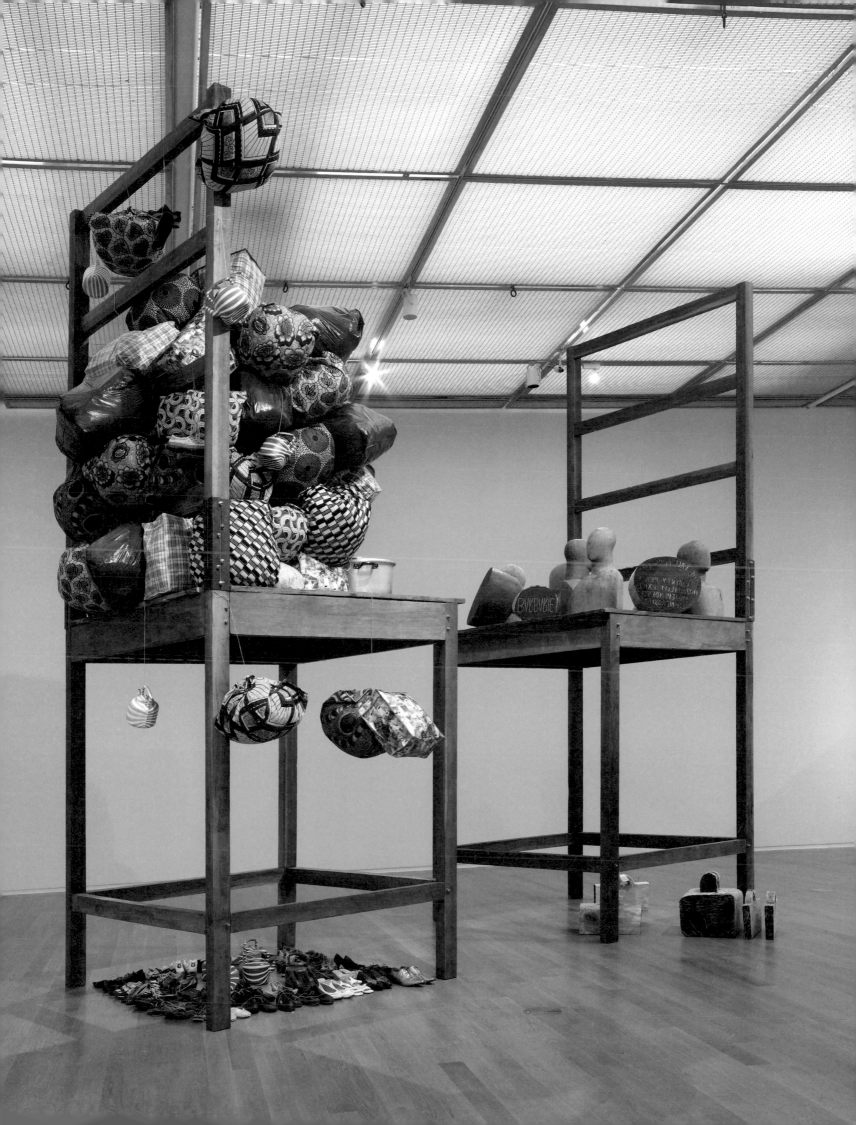

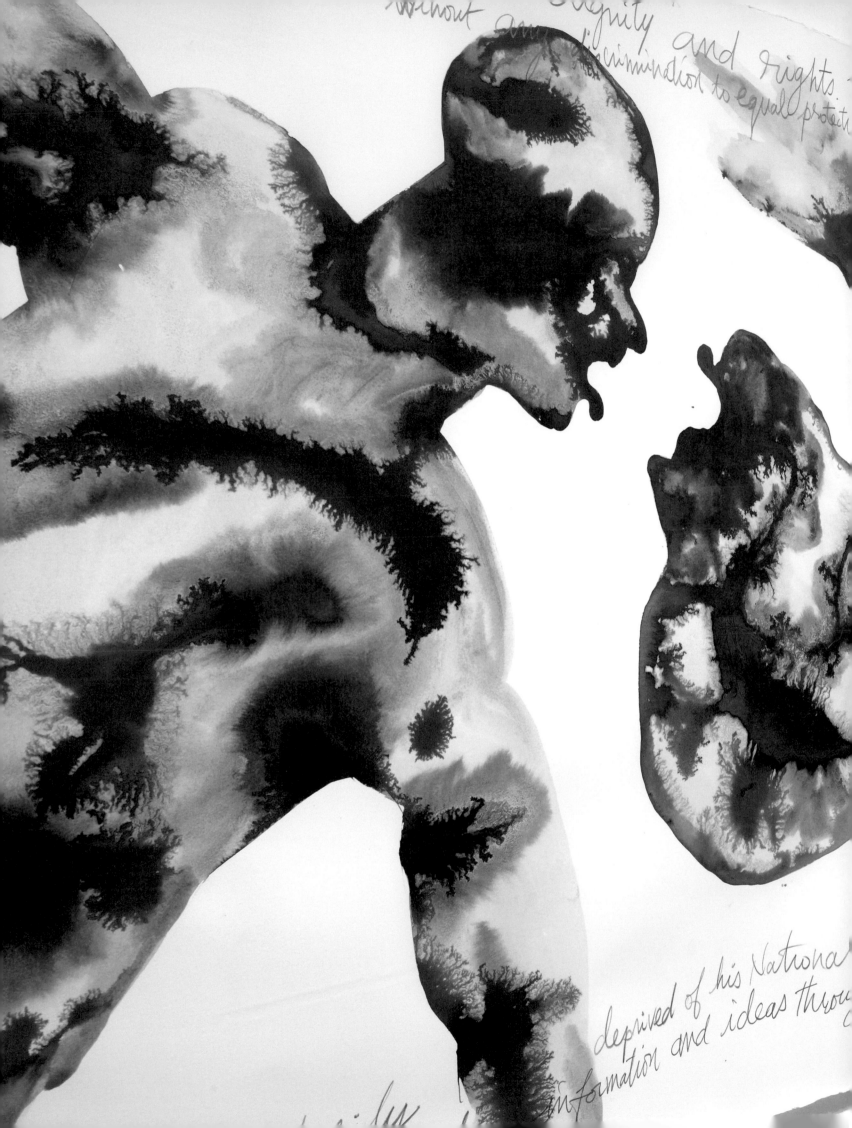

...re endowed with reason and conscience and should conscience and... should act towards one another in a spirit of...

...law. All are entitled to equal protection against any discrimination in violation of this... education and against any...

...to change his nationality / Everyone has the... right to freely... frontiers / Everyone has the right only to participate in the cultural life

nor denied the right... my media and regardless of...

Victoria Udondian

..

Before studying painting, Victoria Udondian trained as a tailor and fashion designer. Her work today is informed by her interest in textiles, in the capacity of clothing to shape identity and the histories and tacit meanings woven into everyday materials.

In 2010, Udondian travelled to Dakar, Accra and Bamako researching the impact second-hand clothing has had on the West African textiles industry and on cultural identity. Interested in confronting notions of 'authenticity' and 'cultural contamination', Udondian tests conceptions of West African textiles against present and past realities, convinced '...that there exists some consequences on the perception of one's identity when the language of the fabrics one wears is changed fundamentally.'

Aso Ikele (1948) made for *We Face Forward* takes the Whitworth's textile collection as its starting point. The collection ranges from textiles made in Manchester for export to the West African market in the eighteenth century, to fabrics by contemporary makers in Mali who supply DKNY with hand-spun cotton.

Combining materials and narratives from Lagos and Manchester, Udondian weaves myths and histories into her own textiles, creating her own hybrids and questioning how stories become histories.

Victoria Udondian
Aso Ikele (1948) 2012

Used clothes from Manchester, UK and printed fabric and burlap from Nigeria
Commissioned by Whitworth Art Gallery, The University of Manchester
Photograph by Michael Pollard
Images courtesy the artist

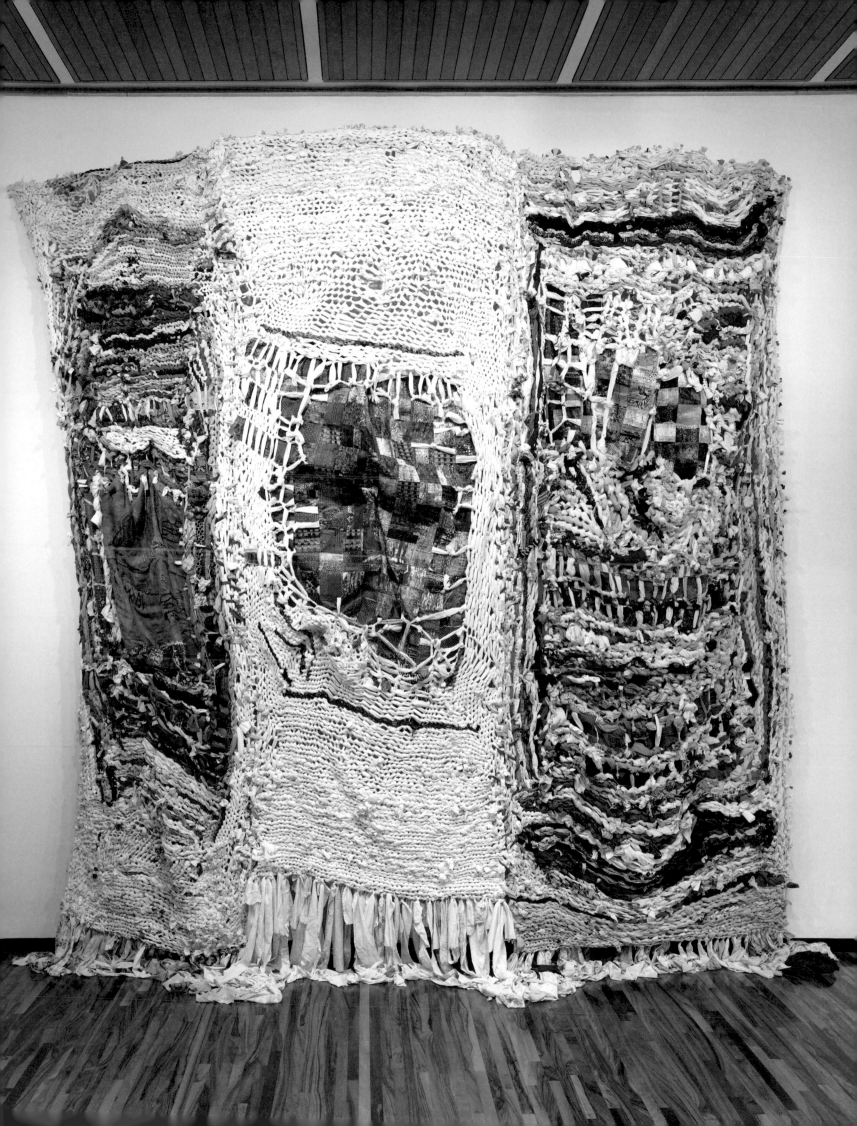

Séraphin Zounyekpe

..

Séraphin Zounyekpe is a photographer and film maker whose subject is daily life in Benin. He wanders the streets with his camera and records what he comes across, documenting events that catch his attention.

Street Vendors (Vendeuses) is a series of photographs of women who sell food, drinks and merchandise on the streets of Cotonou. Balancing heavy containers of carefully arranged products on their heads, they might make one or two Euros a day to supplement the family income. As a collection of images, they communicate a powerful message about the situation of many women.

The format of Zounyekpe's films are one minute. *Under the Bridge (Sous le Pont)* portrays a family forced to live under a bridge near Dantokpa market. The father makes mattresses and his wife is a sweeper and five of their 17 children were born here. The family is susceptible to robbery, bad weather and disease under the bridge. *The Crossing (La traversée)* records the annual flood in Cotonou during the rainy season. People either drive motorbikes through the deep waters or risk walking along the train track. *At the Petrol Station (A La Pompe)* shows a stall selling black market petrol from Nigeria. *The Other Side (L'autre côté)* demonstrates the difficulty pedestrians have in crossing the road due to the heavy traffic. These brief films are like moving photographs, each giving a glimpse into different aspects of daily life in Benin.

Séraphin Zounyekpe
All images *Street Vendors (Les Vendeuses)* 2011

Photographs
Images courtesy the artist and
Stephan Köhler/jointadventures.org

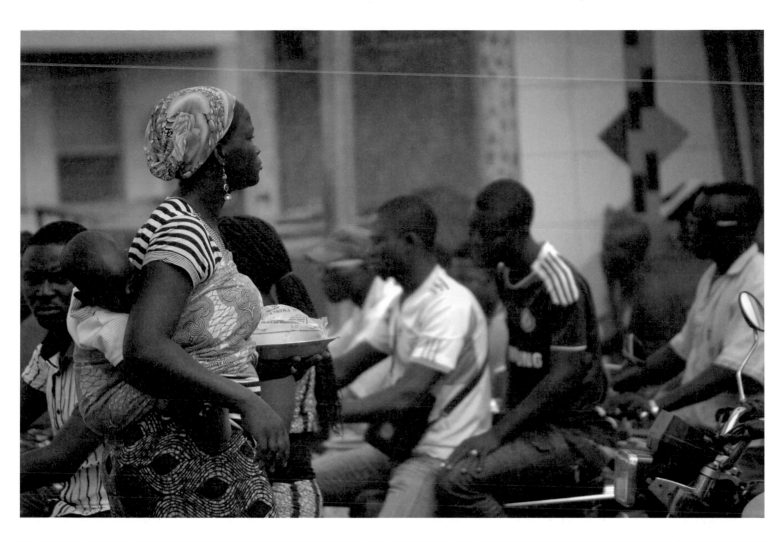

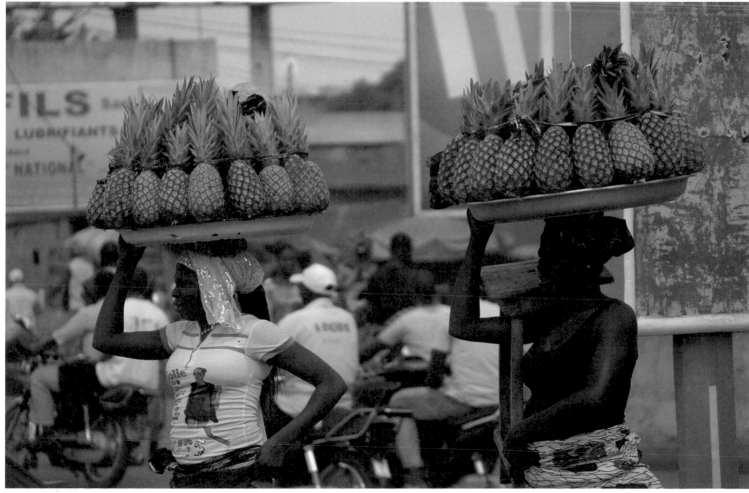

Pascale Marthine Tayou
The World Falls Apart (Le monde s'effondre) 2012

Mixed media installation
Commissioned by Whitworth Art Gallery,
The University of Manchester
Photograph by Michael Pollard
Courtesy the artist and Galleria Continua,
San Gimignano / Beijing / Le Moulin

Artist Biographies

Georges Adéagbo
Born in 1942 in Cotonou, Benin.
Lives and works in Cotonou, Benin.

Studied Law and Business Administration in Adibjan, Ivory Coast and in Rouen, France in the 1960s before returning to Benin. He has never received any formal art training.

Recent solo shows include MUSAC Leon, Spain 2011; MAK, Vienna, Austria, 2009.

Recent group shows include *La Triennale: Intense Proximité*, Palais de Tokyo, Paris, France, 2012; *ARS II*, KIASMA, Museum of Contemporary Art, Helsinki, Finland, 2011; *Fare Mondi*, 53rd Venice Biennale, Italy 2009.

His work is part of major international collections including Philadelphia Museum of Art, USA; Museum Ludwig Cologne, Germany; Toyota Municipal Museum of Art, Japan; KIASMA Museum of Contemporary Art, Helsinki, Finland; MUSAC, Leon, Spain; MAK, Vienna, Austria; LA MOCA, Los Angeles, USA and others.

Hélène Amouzou
Born in 1969 in Togo.
Lives and works in Brussels, Belgium.

Currently studying at the Academy of Drawing and Visual Arts of Molenbeek-St-Jean, Belgium.

Previous shows include *Reflections on the Self: Five African Women Photographers*, a Hayward Touring exhibition, UK; Bozar de Mons, Belgium, 2011/12; Faculté Universitaire Saint Louis, Belgium, 2012; Centre de la Papisserie, Belgium, 2012; Photoquai, Paris, France, 2011; Marché de la photo, Brussels, Belgium, 2010.

El Anatsui
Born in 1944 in Anyako, Ghana.
Lives and works in Nsukka, Nigeria.

Trained as a sculptor at the College of Art, University of Science and Technology in Kumasi, Ghana, before starting to teach at the University of Nigeria, Nsukka in 1975.

Recent solo shows include *El Anatsui: When I Last Wrote to You About Africa* (organised by the Museum for African Art, New York, USA); Royal Ontario Museum, Toronto, Canada, 2010 and USA tour 2011 – 2013; *A Fateful Journey: Africa in the Works of El Anatsui*, National Museum of Ethnology, Osaka, Japan, 2010 and national museum tour; *El Anatsui: Gawu*, Oriel Mostyn Gallery, Llandudno, (in association with October Gallery, London), touring UK, Ireland and USA 2003 – 2008.

El Anatsui's work is regularly shown in group exhibitions internationally and is held in major international collections notably the British Museum, London, UK; The Metropolitan Museum of Art, New York, USA; The Museum of Modern Art, New York, USA; The Centre Pompidou, Musée National d'Art Moderne, Paris, France.

Lucy Azubuike
Born in 1972 in Nigeria.
Lives and works in Atlanta, USA.

Studied at the University of Nigeria, obtaining a BA in Fine and Applied Arts in 1999. She subsequently studied photography under Professor El Anatsui.

Recent shows include *32nd International Expo*, New York, USA, 2010; *Like A Virgin*, Center for Contemporary Art (CCA), Lagos, Nigeria, 2009; Lagos-Paris photography project, France 2009; *Invisible Borders* at *Rencontres de Bamako: Biennale Africaine de la Photographie*, Bamako, Mali, 2009; *Multipist project*, South Africa 2008 – 2009.

pp. 34 – 35

pp. 36 – 37

pp. 38 – 39

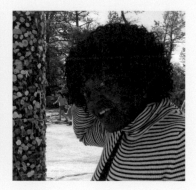

pp. 40 – 41

Mohamed Camara
Born in 1985 in Bamako, Mali.
Lives and works in Bamako, Mali.

...

Major shows include *Paris Photo* France, 2011; *Rencontres de Bamako: Biennale Africaine de la Photographie*, Bamako, Mali, 2009; *Snap Judgments: New Positions in Contemporary African Photography*, Miami and New York, USA, 2006; *Mohamed Camara*, Tate Modern, London, UK, 2004.

His work is part of the Deutsche Bank collection, Maison Européenne de la Photographie, Paris, France; Centre Pompidou, Musée National d'Art Moderne, Paris, France.

Em'kal Eyongakpa
Born in 1981 in Cameroon.
Lives and works in Cameroon.

...

Studied for a post-graduate diploma in Botany and in Ecology at the University of Yaoundé, Cameroon.

Solo exhibitions include *Objectifs*, Doual'art, Douala, Cameroon; performance of *SUN is the MOON*, Goëthe Institut, Yaoundé, Cameroon.

Group exhibitions include *Rencontres de Bamako: Biennale Africaine de la Photographie*, Bamako, Mali, 2009; *Synchronicity*, Galerie Baudoin Lebon, Paris, France, 2011, ; *Mo(ve)ments*, Bag Factory, Johannesburg, South Africa, 2011; *GAIA: Art Contemporain Aricaine*, Atelier Richelieu, Paris, France, 2009.

Aboubakar Fofana
Born in 1967 in Bamako, Mali.
Lives and works between Mali and France.

...

His practice includes calligraphy and textile design specialising in natural indigo.

Recent solo shows include *Histoires de Fils*, Ivry, France 2007; *Signs of the times*, Gallery Shin-Bi, Kyoto, Japan, 2006; *Traces et Empreintes*, Le Quai, Ecole Supérieure des Arts de Mulhouse, France, 2004; *Sublime Indigo*, works from the Bamako workshop, atelier Blaise Patrix, Brussels, Belgium and Potrona Frau showroom, Paris, France, 2003.

Recent group shows include *Cotton: Global Threads*, Whitworth Art Gallery, Manchester, UK, 2012; *La Lune Bleue*, Galerie du Manege, Institut Français L.S.Senghor, Dakar, Senegal, 2007; *Art-Design*, Galerie Beckel-Odille-Boicos, Paris, 2006; *Sawura*, Gallery Marufuku, Kyoto, Japan, 2006; *Animismes*, Galerie Da Vinci, Nice, France, 2005; *Dak'Art, Biennale de l'Art Contemporain de Dakar*, Senegal, 2002.

In 2004, he won the *Villa Kujoyama / AFAA* prize, Kyoto, Japan. In 2001, he won the Villa *Medicis hors les murs / AFAA* prize for his project *Sublime Indigo*.

Meschac Gaba
Born in 1961 in Cotonou, Benin.
Lives and works in Rotterdam, The Netherlands.

...

He emerged on the international art scene with his twelve part project, *The Museum of Contemporary Art*, 1997– 2002 which concluded at *Documenta XI*, Kassel, Germany.

Group shows include the Dutch Pavilion at the 50th Venice Biennale, 2003; *Africa Remix* international tour including Hayward Gallery, London, 2004-07.

François-Xavier Gbré
Born in 1978 in Lille, France.
Lives in Bamako, Mali and works
between Europe and West Africa.

..

Born in Lille, France to a French
mother and an Ivorian Coast
father, Gbré studied at the
Ecole Supérieure des Métiers
Artistiques, Montpellier, France.

Recent shows include
Synchronicity II, Tiwani
Contemporary, London, 2012; *9th
Rencontres de Bamako: Biennale
Africaine de la Photographie*,
Bamako, Mali, 2011; *Synchronicity
– Photoquai*, Galerie Baudoin
Lebon, Paris, France, 2011;
Margate Photo Fest, Margate, UK,
2011; 9th International Fashion
Photography Festival, Cannes,
France 2011.

Second prize in *PhotoAfrica*, 2010.

Romuald Hazoumè
Born in 1962 in Porto-Novo,
Republic of Benin.
Lives and works in Benin.

..

Solo shows include *Romuald
Hazoumè*, Irish Museum of
Modern Art (IMMA), Dublin, 2011
(touring); *Romuald Hazoumè: My
Paradise – Made in Porto-Novo*,
Gerisch-Stiftung, Neumünster,
Germany, 2010; *Romuald
Hazoumè: Made in Porto-Novo*,
October Gallery, London, UK,
2009; *La Bouche du Ro*i, British
Museum, 2007, followed by a
national UK tour; *Documenta XII*,
Kassel, Germany, 2007; *La Bouche
du Roi*, Musée du Quai Branly,
Paris, France, 2006.

Hazoumè's work is regularly
shown in international group
exhibitions and is held in the
collections of the British Museum,
the Jean Pigozzi Collection and
the Queensland Art Gallery,
Brisbane, Australia.

Abdoulaye Armin Kane
Born in 1965 in Dakar, Senegal.
Lives and works in Dakar, Senegal.

..

Studied at the Academy of Arts in
Dakar from 1988 to 1992.

Exhibitions include *Dak'Art*, 2008,
Festival du Film de Dakar, 2009;
Festival Bouillants Numeriques,
Rennes, France, 2012; Galerie
Nationale d'Art, Dakar, 2011
and 2008; *CRUNCHTIME2010*,
international visual arts festival,
York, UK.

Solo shows include Galerie
Nationale d'Art, Dakar, Senegal,
2006.

Abdoulaye Konaté
Born in 1953 in DIré, Mali.
Lives and works in Bamako, Mali.

..

Studied painting in Bamako and
then in Havana, Cuba for seven
years.

Major group shows include
Documenta XII in 2007 and *Africa
Remix* international tour including
Hayward Gallery, London, UK,
2004-7.

In 2008 Konaté was nominated for
the Artes Mundi prize, Cardiff, UK.

Konaté has received several
awards, including in 2002 the
Chevalier de l'Ordre National du
Mali and Chevalier de l'Ordre des
Arts et des Lettres de France.

He is Director of the Conservatoire
for Arts and Media in Bamako,
Mali.

pp. 50 – 51

pp. 52 – 53

pp. 54 – 55

pp. 56 – 57

Hamidou Maiga
Born in 1932 in Burkina Faso.
Lives and works in Bamako, Mali.

Recent solo shows include *Talking Timbuktu*, Jack Bell Gallery, London, UK, 2011.

Recent group shows include *Material, Salon 94*, New York, USA, 2012; *Les Fantômes*, Jack Bell Gallery, London, UK, 2011.

Maiga's photographs are part of the Victoria & Albert Museum Collection, London and Manchester City Galleries.

Soungalo Malé
Born in 1920 in Mali.
Died in 2002 in Mali.

Trained with Seydou Keita in Bamako, Mali before opening his own studio in San in 1958.

Nii Obodai
Born in 1963 in Accra, Ghana.
Lives and works in Accra, Ghana.

Previous exhibitions include *Neither Black Nor White*, Studio Kurtycz, Accra, Ghana, 2011; *Identity Bluffs*, Stedlijk Museum, Amsterdam, The Netherlands, 2011; *For a Sustainable World*, Bamako, Mali, 2011; *Africa: See You See Me*, Lisbon, Portugal, 2010; *Who Knows Tomorrow*, Alliance Française, Accra, Ghana, 2009; *Another World*, Bamako, Mali, 2005.

He has taken part in residencies at the Watershed, Bristol, 2007 and the Cité Internationale des Arts, Paris, 2005.

Ongoing projects include *Who Knows Tomorrow* with Bruno Boudjelal; *Liberation of Soul*, a travelogue exploring the future of Africa; *Negotiating Spaces* working with an urban slum community in Accra, Ghana, out of which he has created a short photographic film, *The MisAlignment of a Polarised Black Star; Mentation*, a three minute black and white video film on Thai Kick Boxing; *The Beautyful Ones Are Not Yet Born*, a collective exhibition involving the artists of La, a neighbourhood in Accra, Ghana.

Emeka Ogboh
Born in 1977 in Enugu, Nigeria.
Lives and works in Lagos, Nigeria.

Obtained a BA in Fine and Applied Arts from the University of Nigeria, Nsukka in 2001. He is the co-founder of the Video Art Network, Lagos and a member of the African Centre for Cities project on African Urbanism.

Recent shows include *Invisible Cities*, Massachusetts Museum of Contemporary Art, USA, 2012; *ARS II*, KIASMA, Museum of Contemporary Art, Helsinki, Finland, 2011; *Imag[in]ing Cities* at the Amin Gulgee Gallery, Karachi, Pakistan 2011; *The Green Summary*, Centre for Contemporary Art, Lagos, Nigeria, 2010; *Afropolis*, Rautenstrauch-Joest Museum, Cologne, Germany, 2010.

pp. 58 – 59

pp. 60 – 61

pp.62 – 63

pp. 64 – 65

Abraham Oghobase

Born in 1979 in Lagos, Nigeria.
Lives and works in Lagos, Nigeria.

Studied at the Yaba College of Technology – School of Art, Design and Printing, majoring in photography.

His work has been exhibited in his home country of Nigeria and across Africa and Europe including *ARS II*, KIASMA, Museum of Contemporary Art, Helsinki, Finland, 2011; *Synchronicity II*, Tiwani Contemporary, London, UK, 2012.

Amarachi Okafor

Born in 1977 in Nigeria.
Lives and works. in Nigeria.

Trained in Nigeria where she obtained a BA in Painting and an MFA in Sculpture from the University of Nigeria in 2002 and 2007 respectively. She is currently studying an MA in Curating at the University College Falmouth, Cornwall, UK.

Recent solo shows include *Africa West*, Oriel Mostyn Gallery, Llandudno, UK, 2008. Group shows include *Shared Perspectives,* Cameroon, 2010; the 1st International Festival of Contemporary Art, Algiers, 2009; ARESUVA, 2008, Abuja, Nigeria, 2008 and Art 4, Channel Four Television Headquarters, London, UK, 2008.

She worked as a curatorial assistant at the National Gallery of Art, Abuja, Nigeria in 2009 and curated an artist intervention project in the Bahamas in 2010, *I am Bahamian, I eat Conch Salad* funded by the Commonwealth Foundation.

Charles Okereke

Born in 1966 in Nigeria.
Lives and works in Lagos, Nigeria.

Following an apprenticeship with a commercial arts publishing company, he studied at the University of Port Harcourt in Nigeria graduating with a BA in Visual Arts with a specialisation in Sculpture in 1996. He is a member of the photographic group Black Box Collective and is also a founding-member of the Trans-African Photographic Road Trip, *Invisible Borders*.

Recent shows include *9th Rencontres de Bamako: Biennale Africaine de la Photographie*, Bamako, Mali, 2011; *Mapping the Flâneur*, Format International Festival, (Black Box Collective), Derby, UK, 2011; *World Black Arts Festival/ Invisible Borders* in Dakar, Senegal, 2010; *The Idea of Africa (re-invented)*, Kunsthalle Bern, Switzerland, 2010; and the *3rd Photo Africa*, Tarifa, Spain, 2010.

Nnenna Okore

Born in 1975 in Australia.
Lives in Chigago, USA.

Raised mostly in Nigeria, Okore trained at the University of Nigeria, obtaining a BA in Painting in 1999 followed by an MA and MFA in Sculpture at the University of Iowa, USA in 2004 and 2005 respectively. She is currently Associate Professor of the Art Department at North Park University, Chicago, USA, and has been named a 2012 recipient of the Fulbright Scholar Award.

Recent solo shows include *Metamorphoses*, October Gallery, London, UK, 2011; *Textile*, Blachère Fondation Art Center, Apt, France, 2010; *Africa West*, Oriel Mostyn Gallery, Llandudno, UK, 2008 and *Reflection*, Contemporary African Art Gallery, New York, USA, 2007.

Group shows include *Environment and Object in Recent African Art,* Middlebury College Museum of Art, Vermont, USA, 2012 and the Tang Museum, Skidmore College, New York College, USA, 2011; and the 29th Sao Paulo Biennial, Sao Paulo, Brazil, 2010.

Her work is also part of major private collection, including the Jean Paul Blachère Fondation, France, the Royal Collections in Abu Dhabi, UEA and the Channel 4 Collection, UK.

pp. 66 – 67

pp. 68 – 69

pp. 70 – 71

pp. 72 – 73

Duro Olowu

Born in 1965 in Lagos, Nigeria.
Lives and works in London, UK.

Studied law at The University of Kent in Canterbury before returning in 1988 to practise in Nigeria. By 1997, he had moved back to London to pursue a career in fashion.

He launched his first women's wear label in 2004 featuring his signature 'Duro dress' hailed by both British Vogue and American Vogue as the dress of the year. He won the New Designer of the Year award at the British Fashion Awards in 2005. He was awarded the NEWGEN Sponsorship by Topshop in 2007. He collaborated with the artist and photographer Juergen Teller for a cover and shot for TANK magazine, 2008 and again on a special issue of self service magazine in 2009. He won the Best Designer award at the African Fashion Awards in South Africa and was one of six shortlisted finalists for the Swiss Textiles Awards held by the Swiss Textiles Federation in Zurich in 2010.

His work featured in the *Global Africa Project* exhibition at the Museum of Art and Design in New York, USA 2010; in the publication *New African Fashion* by Helen Jennings, published by Prestel in 2011 and he curated *Material*, Salon 94 Gallery, New York, USA, 2012.

George Osodi

Born in 1974 in Lagos, Nigeria.
Lives and works in Lagos, Nigeria.

Studied Business Administration at the Yaba College of Technology in Lagos before working as a photojournalist for the Comet Newspaper in Lagos from 1999-2001. He then joined the Associated Press News Agency in Lagos from 2001 to 2008.

Recent solo exhibitions include: *9th Rencontres de Bamako: Biennale Africaine de la Photographie*, Bamako, Mali, 2011; Raw Material Company, Dakar, Senegal, 2011; Galerie Peter Hermann, Berlin, Germany, 2009.

Recent group shows include: *Environment and Object, Present African Art*, Tang Museum, Skidmore College, Saratoga, New York, USA, 2011; *Ghana Gold – De Money* at the 6th *Curitiba* Biennial, Brazil 2011; *Uneven Geographies*, Nottingham Contemporary, UK, 2010; *Afrika in Oslo*, National Museum of Contemporary Art, Oslo, Norway, 2009; *Documenta XII*, Kassel, Germany, 2007.

His work is part of major international collections including the Smithsonian Museum, Washington, USA; EMET, National Museum of Greece; Martin Marguiles Collection in Miami, USA and Museumslandschaft Hessen Kassel, Germany.

Nyaba Léon Ouedraogo

Born in 1978 in Burkina Faso.
Lives and works between France and West Africa.

Trained as an assistant to Jean-Paul Dekers in Paris, France.

Recent solo shows include: *Galerie Particulière*, Paris, France, 2012; *9th Rencontres de Bamako: Biennale Africaine de la Photographie*, Bamako, Mali, 2011; *Children of Bahia*, Angers, France, 2009; *On the Spot*, Paris, France, 2006 and *Contemporary Wheeling and Dealing*, Morocco, 2004.

Recent group shows include: *9th Rencontres de Bamako: Biennale Africaine de la Photographie*, Bamako, Mali, 2011; *Prix Pictet*, Paris, France, 2011 followed by an international tour; *Climate Change*, Mexico, 2010.

He was the winner of the *Union Européenne Prize* 2011 and *Fondation Blachère Prize*, 2011. Other awards and prizes include being shortlisted for the *Prix Pictet* 2010; *La Planète Manche* International Prize 2010; *Coup de Coeur Prize* for the *Bourse du Talent* 2009 and 2010.

Piniang

Born in 1976 in Dakar, Senegal.
Lives and works in Dakar, Senegal.

Trained at the Ecole Nationale des Arts, from 1995 to 1999 and at the Pictoon Studio in Dakar, Senegal. He runs the Digital Arts course at the Ecole Nationale des Arts, Dakar, Senegal.

Recent shows include: Galerie le Douze, Nantes, France, 2010 – 2011; The Bronx Museum of the Arts, New York, USA, 2010; Dak'Art Biennale de l'Art Contemporain de Dakar, Senegal, 2008; *Malmö Dakar*, Muséum Malmö, Sweden, 2008.

He has taken part in numerous workshops include at the Ecole des Beaux-Arts, Rennes, France in 2010 and the Danish Centre for Art and Craft, Copenhaguen, Denmark, 2010.

His work is part of major international collections including the Museum Malmö, Sweden, World Bank, Washington DC, USA and the Fondation Jean Paul Blachère, Apt, France.

pp. 74 – 75

pp. 76 – 77

pp. 78 – 79

pp. 80 – 81

Nyani Quarmyne
Born in 1973 in India.
Lives and works in Accra, Ghana.

...

Clients and publications
include the African Women's
Development Fund, the Australian
Agency for International
Development, BasicNeeds, the Bill
and Melinda Gates Foundation,
CHF International, The Coca-Cola
Africa Foundation, The Herald
Magazine (UK), The Independent
(UK), the Institute of Development
Studies, the International
Development Research Centre,
the Internet Society, ONE, Save
the Children, The Sunday Times
(Australia), and UNICEF, amongst
others.

Joint winner for press / reportage
photography at *9th Rencontres
de Bamako: Biennale Africaine de
la Photographie*, Bamako, Mali,
2011.

Abderramane Sakaly
1926 – 1988, Mali.

...

Trained as a photographer in
Saint Louis, Senegal. Established
a studio in Bamako, Mali in 1956.
First president of Groupement
National des Photographes du
Mali in 1988 .

Amadou Sanogo
Born in 1977 in Ségou, Mali.
Lives and works in Bamako, Mali.

...

Studied Fine Art at Bamako's
prestigious Institut National des
Arts (l'INA) and Institut des Arts
Plastiques.

Shows include *Museos y
Modernidad en Transito*, at the
Museo de America, Madrid,
Spain, 2012; *Le Trait*, the Centre
Culturel Français de Bamako,
Mali, 2011; *Au dela du cadre*, the
artist's house, Bamako, Mali,
2010; *Fiches d'identification*,
itinerant exhibition in different
neighborhoods in Bamako, Mali,
2009 (during *9th Rencontres de
Bamako: Biennale Africaine de
la Photographie*, Bamako, Mali,
2011); *Terrains vagues*, Quartier
Orange, Bamako, Mali, 2009.

He took part in a residency at
MC2a in Bordeaux, France in 2010.

Malick Sidibé
Born in 1935/36 in Mali.
Lives and works in Mali.

...

Solo exhibitions include
Fotografiemuseum Amsterdam,
The Netherlands, 2008; CAV
Coimbra Visual Arts Centre,
Coimbra, Portugal, 2004;
Hasselblad Center, Göteborg
Museum of Art, Gothenburg,
Sweden, 2003–2004; *You look
beautiful like that : The Portrait of
Photographs of Seydou Keïta and
Malick Sidibé*, Fogg Art Museum,
Harvard University Art Museums,
USA and the National Portrait
Gallery, London, UK, 2001–2003;
Galleria Nazionale d'Arte
Moderna, Rome, Italy , 2001;
Stedelijk Museum, Amsterdam,
The Netherlands, 2001; Centre
d'Art Contemporain, Geneva,
Switzerland, 2000.

Prizes include the Hasselblad
Award for Photography in 2003;
the 52nd Venice Biennale's Golden
Lion for lifetime achievement
award in 2007 and the ICP Infinity
Award for Lifetime Achievement
2008.

pp. 82 – 83

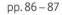
pp. 86 – 87

pp. 88 – 89

pp. 90 – 91

Pascale Marthine Tayou
Born in 1966 in Cameroon.
Lives and works between Cameroon
and Belgium.

Recent solo shows include *Black Forest*, MUDAM, Luxembourg; *Always All Ways (tous les chemins mènent à ...) MACLyon*, Lyon 2011 – Malmö Konsthall, Sweden 2010; *Traffic Jam*, Gare Saint Sauveur, Lille, France 2010; *Transgressions*, Galleria Continua, San Gimignano, Italy 2010; *KIOSK Royal*, KIOSK, Gent, Belgium 2008.

Recent group shows include, 4th Marrakech Biennale, Marrakech, Morocco 2012; *Le Musée – Monde*, Musée du Louvre, Paris, France, 2011; *Beijing Online Inlive – 10 Hands 100 Fingers*, Galleria Continua, Beijing, China 2011; *The New Décor*, Garage Center for Contemporary Culture, Moscow, Russia, 2010; 53rd Venice Biennale 2009; *Un certain état du monde?*, Garage Center for Contemporary Culture, Moscow, Russia 2009; *Altermodern*, 4th Tate Triennial, Tate Britain, London, UK, 2009; *Documenta XI*, Kassel, Germany 2002

Barthélémy Toguo
Born in 1967 in Cameroon.
Lives and works between Cameroon,
France and USA.

Trained at the Ecole Nationale Supérieure des Beaux-Arts, Abidjan, Ivory Coast, the Ecole Supérieure d'Art, Grenoble, France and the Kunstakademie, Düsseldorf, Germany.

Recent solo shows include:
A World Child Looking at the Landscape, Nosbaum & Reding Art Contemporain, Luxembourg, 2012; *The Well Water and Shower Life*, La Verrière by Hermès, Brussels, Belgium, 2011; International Print Biennale, Hatton Gallery, Newcastle, UK, 2011; *The Lost Dogs' Orchestra*, Galerie Lelong, Paris, France, 2010.

Recent group shows include: *La Triennale: Intense Proximité*, Palais de Tokyo, Paris, France, 2012; 11th Havana Biennial in Cuba, 2012; *A terrible beauty is born*, Biennale de Lyon, France; 18th Sydney Biennale, *Laughing in a Foreign Language*, Hayward Gallery, London, 2008.

In 2011, he was made Knight in the Order of Arts and Literature, France.

His work is part of major international art collections including the Centre Georges Pompidou, Paris, France; MOMA, Museum of Modern Art New York, USA; Museum of Contemporary Art of Miami, USA and Kunstsammlungen der Stadt, Düsseldorf, Germany.

Victoria Udondian
Born in 1982 in Nigeria.
Lives and works in Nigeria.

Studied at the University of Uyo graduating with a BA in Painting in 2004. She is an active member of various art groups and collectives, including the Society of Nigerian Artists (SNA) and the Catalyst Women Arts and Science in Portsmouth, UK since 2008.

Recent shows include *SAS*, the Bag Factory Studios, Johannesburg, South Africa, 2012; *A Kilo of Hope*, Yusuf Grillo Gallery, Yaba College of Technology, Lagos, Nigeria 2011; *The Green Summary*, Centre for Contemporary Arts (CCA), Lagos, Nigeria, 2010; *Who is Wearing My T-shirt?* Centre for Contemporary Arts (CCA), Lagos, Nigeria, 2010; *Hidden Drama*, King's Theatre, Southsea, UK 2010.

Artist residencies include the Art Enclosures for the Fondazione di Venezie, Italy 2011 and the Centre for Contemporary Arts (CCA) / Triangle Arts Trust Artist Residency in Nigeria, 2010.

Séraphin Zounyekpe
Born in 1970 in Benin.
Lives and works in Benin.

In 2007, he won the Award for Best Documentary Film of One Minute and participated in the *World One Minute Exhibition*, Today Art Museum, Beijing, China, 2008. Previous awards include third prize for the film *l'Autre Côté* in Belgium and Croatia, 2011; official selection with the film *Kluito2* at the Croatian one minute film festival, 2011; second prize for the film *Noël au Village* in Belgium, 2009. From 2009-11, he was the official photographer of the Chinese Cultural Centre.

pp. 92 –95

pp. 96 –99

pp. 100 –101

pp. 102 –103

Author Biographies
Maria Balshaw

Bryony Bond

Christine Eyene

Mary Griffiths

Maria Balshaw has been Director of the Whitworth Art Gallery since June 2006. She has coordinated a challenging programme of historic, modern and contemporary exhibitions that capitalise on the Whitworth's university location as well as having a strong international profile. She has led a successful £12 million campaign, supported by the Heritage Lottery Fund, to expand the gallery and reconnect it to the surrounding park as well as modernise and revitalise the whole gallery.

In 2011 she took on the role of Director of Manchester City Galleries alongside her duties at the Whitworth. This dual Directorship represents a unique partnership between the University of Manchester and Manchester City Council, bringing the two institutions and Manchester's historic and modern art collections into complementary alliance for the first time in their history. Retaining their separate governance arrangements and their distinctive personalities the two Galleries are evolving complementary programmes and joint exhibition projects that build on the strength of the city collections and a spirit of Manchester radicalism.

Maria secured a Paul Hamlyn Breakthrough Award in 2010, a £260,000 grant in recognition of her exceptional cultural entrepreneurship, which has helped support *We Face Forward*. Before moving to work in the cultural sector Maria worked as Research Fellow in Urban Culture at the University of Birmingham and as lecturer in Cultural Studies at University College Northampton. She published a number of books and essays on African-American urban culture, gender and visuality.

Bryony Bond is Exhibitions Curator (Temporary) at the Whitworth Art Gallery. She curated *Intuition* a selection of works from the Musgrave Kinley Outsider Art Collection, a recent gift of over 700 artworks to the Whitworth, and helped organise *Projections: Works from the Artangel Collection*.

She is the Editor of Corridor8 magazine, a journal of contemporary visual art and new writing based in the north of England, and is also the Consultant for contemporary art projects at National Museums Scotland, Edinburgh, curating an exhibition of selected objects and new work by Melvin Moti, *One Thousand Points of Light*.

Previously she worked at Camden Arts Centre, London, on exhibitions by Eva Hesse and Katja Strunz and at A Foundation, Liverpool where she worked on new commissions by Goshka Macuga and Brian Griffiths, and exhibitions *Port Cities* (touring from Arnolfini, Bristol), Haroon Mirza and Ben Rivers. From 2003 to 2008 she ran the Alchemy residency programme at the Manchester Museum, commissioning new works by artists including, Jordan Baseman, Pavel Büchler, Mark Dion, Ilana Halperin and Jamie Shovlin.

She is a trustee of Pavillion, a visual arts commissioning organisation based in Leeds.

Christine Eyene is an art critic, independent curator and consultant. She is co-curator of *Dak'Art 2012* – Biennale of Contemporary African Art. In 2011 she curated the African selection of the *3rd edition of Photoquai – Biennial of World Images*, Musée du Quai Branly, Paris, Sept. 2011; Gwanza 2011 – *Month of Photography*, National Gallery of Zimbabwe, Harare, August 2011; *FOCUS11 – Contemporary Art Africa*, as part of Art|42|Basel's Public Program, June 2011.

Her other projects include: *Reflections on the Self – Five African Women Photographers*, (Hayward Touring Exhibition), Royal Festival Hall, London and touring the UK (2011-2014); and *[Kaddu Jigeen] La Parole aux Femmes*, Galerie le Manège, Dakar and touring (2011-2012). She is contributor and co-editor with Katrina Schwarz of *Seeing Ourselves* (Milan: Charta, 2011), catalogue of the Zimbabwe Pavilion at the 54th Venice Biennale.

Prior to working as an independent curator, Eyene was consultant for PUMA from 2008 to 2010. In this role, she developed the initial phase of the website Creative Africa Network and fostered the partnership between puma.creative and the 8th Bamako Encounters (2009). From 2006 to 2009 she was publishing director of *Africultures*, a journal to which she has been contributing since 2002.

She sits on a number of committees including Art Moves Africa (2012-2013) and the Institut Français' Visa pour la Création. She was also member of the jury of the Fondation Blachère Prize awarded at the *Dak'Art Biennale* in 2008 and 2010, and the Bamako Encounters in 2007 and 2009.

Mary Griffiths has been Curator of Modern Art at the Whitworth Art Gallery, University of Manchester since 2000. Previously she worked in collections and exhibitions at Manchester Art Galleries, the Potteries Museum in Stoke on Trent, and the National Media Museum in Bradford.

At the Whitworth, she is developing the modern collection, acquiring works of art that resonate with and yet challenge the existing collection. She also curates exhibitions from the Whitworth's collection and from beyond, including *Autonomous Agents: the art and film of Lynn Hershman Leeson; The Land Between Us: power, place and dislocation* and *Projections: Works from The Artangel Collection*. She has co-curated *Marina Abramovic Presents…*, for the Manchester International Festival. Over the next two years, the Whitworth will complete a building programme that will see the gallery increase significantly in size. For the re-opening of the gallery, Mary is working on several commissions and exhibitions.

Mary is a member of the Arts Council Collection Acquisitions and Advisory Committee.

Lubaina Himid

Lubaina Himid is Professor of Contemporary Art at the University of Central Lancashire. During the past 30 years she has exhibited widely both in Britain and internationally with solo shows that include Tate St Ives, Transmission Glasgow, Chisenhale London, Peg Alston New York and St Jorgens Museum in Bergen. Lubaina represented Britain at the 5th Havana Biennale and has shown work at the Studio Museum in New York, Track 17 in Los Angeles, the Fine Art Academy in Vienna and the Grazer Kunstverein. She has work in several public collections including Tate, The Victoria & Albert Museum, Whitworth Art Gallery, Arts Council England, Manchester Art Galleries, The International Slavery Museum Liverpool, The Walker Art Gallery, Birmingham City Art Gallery, Bolton Art Gallery, New Hall Cambridge and the Harris Museum and Art Gallery.

Lubaina Himid's work investigates historical representations of the people of African diaspora and highlights the importance of their cultural contribution to the contemporary landscape. Himid was one of the pioneers of the Black Art movement in the 1980's which offered a forum for black artists exploring the social and political issues surrounding black history and identity. She has participated at an international level in exhibitions, publications and conferences, recently co-curating *Thin Black Line(s)* at Tate Britain. Though she is known as a painter, recently her work has engaged with museum collections in which she has creatively interrogated the history and representation of the African diaspora and looked at the role of museums in discussion around cultural histories. She celebrates black creativity and the recognition of cultural contribution.

Natasha Howes

Natasha Howes is a curator at Manchester Art Gallery where she has curated solo exhibitions of Michael Craig-Martin, Tom Hunter, Nick Crowe and Ian Rawlinson, Dryden Goodwin, Xie Nanxing, Susie MacMurray, Zhao Bandi and Paul Morrison. She has organised group exhibitions including *Visions of Zimbabwe* and *Beyond the Endgame: Abstract painting in Manchester* and is currently co-curating *The First Cut* which opens in October 2012. Natasha is involved in purchasing contemporary art work for the collection.

Previously she was the exhibition co-ordinator at Ikon Gallery, Birmingham where she organised exhibitions and catalogues of Nancy Spero, Georgina Starr, Martha Rosler, Gordon Bennett, Richard Billingham and LOST (curated by artist Tania Kovats). Prior to that she was curatorial assistant at The Barber Institute of Fine Arts, Birmingham working with the historic collection.

Freelance projects include curating *We are no longer ourselves* for Site Gallery, Sheffield and university and public lectures.

Koyo Kouoh

Koyo Kouoh is a Cameroonian born independent curator and cultural producer educated in banking administration, cultural management and curatorial practice in Switzerland, France and the United States. She is the founder and artistic director of Raw Material Company, Dakar, Senegal. Specialising in photography, video and public interventions, she has curated exhibitions in Brazil, Switzerland, Austria, Germany and the United States and written extensively on contemporary African art.

Recent projects Koyo Kouoh has been involved includes Documenta 13, Kassel, Germany; *Make Yourself At Home: Contemporary Hospitality in a Changed World*, an exhibition curated in collaboration with Charlotte Bagger-Brandt for Kunsthal Charlottenborg, Copenhagen, Denmark and *Geo-Graphics: A Map of Art Practice in Africa, Past and Present* curated with David Adjaye and Anne-Marie Bouttiaux to celebrate 50 years of African independences at Palais des Beaux Arts, Brussels, Belgium. Koyo Kouoh lives and works in Dakar.

Alan Rice

Alan Rice is a Professor in English and American Studies at the University of Central Lancashire and is an expert in the emerging field of Black Atlantic Studies. He has published widely in African American Studies and Transatlantic Cultural Studies He was academic advisor to and board member of the Slave Trade Arts Memorial Project (STAMP) in Lancaster that was responsible for the commissioning and building of the first British quayside monument to the victims of the slave trade unveiled in Lancaster in October 2005. He has given public lectures and keynote presentations in Britain, Germany, the United States and France and contributed to documentaries for the BBC, Border Television and public broadcasting in America. His latest book is *Creating Memorials, Building Identities: The Politics of Memory in the Black Atlantic*. Images and information relevant to the book can be found at www.uclan.ac.uk/abolition

Alan co-curated the exhibition *Trade and Empire: Remembering Slavery* at the Whitworth Art Gallery in Manchester, which opened in June 2007. During the Commemorations of the Bicentenery of the Abolition of the Slave Trade in 2007, he took part in numerous workshops in Britain and beyond, but especially in the North West. In Manchester he was an advisor and deliver of content to the *Revealing Histories* consortium of museums in Greater Manchester, becoming the content editor of the website for the project. The website is still live at www.revealinghistories.org.uk

We Face Forward: The Music
Band on the Wall

The music of West Africa is as rich and diverse as its landscape, which stretches from the arid vistas of the Sahara to the azure waters of the Atlantic. It is characterised by some of the most uniquely distinctive instruments in existence - like the *kora*, *djembe* and *talking drum*. Band on the Wall is proud to be involved in bringing some of the best music the region has to offer to Manchester for *We Face Forward*, in a series of concerts and events across the city.

We couldn't ask for a better season opener than the incredible AfroCubism project – the 'supergroup' whose Malian contingent's non-appearance at a 1996 Havana recording session meant the creator of the Buena Vista Social Club would wait another 14 years to hear the cross-cultural collaboration as he originally intended. Their incredible line-up includes Eliades Ochada, Toumani Diabaté and Bassekou Kouyate, and explores the cultural lineage between Cuba and West Africa.

Femi Kuti

Manchester has the great fortune to be the city the legendary Kanda Bongo Man now calls home; as the man who revolutionised *Soukous* music and invented the *Kwassa Kwassa* dance, we had to invite him to join in the celebrations.

Nigeria is the country that gave us *Afrobeat*, and the man who brought it to the world's attention is the late, great Fela Kuti. Keeping the Afrobeat flame burning is his son Femi Kuti, who will perform his explosive live show at an exclusive UK concert in support of *We Face Forward*. We continue the Fela Kuti celebrations with a tribute performance by his legendary keyboard player Dele Sosimi and his Afrobeat orchestra at Band on the Wall.

The melodic *kora*, a 21-stringed bridge-harp, is probably the most instantly recognisable African instrument and features in four of our concerts, including the AfroCubism show. Jaliba Kuyateh and the Kumareh Band from Ghana, and Seckou Keita and Diabel Cissokho from Senegal will also showcase this most majestic and joyous of instruments.

Seckou Keita
Image courtesy Paolo Hollis

The Sahara Desert, and the challenges of living and travelling within it, are the subject of an inspiring concert, film and digital exhibition *The Endless Journey*, featuring Mamane Barka and Oumarou Adamou, with Alhousseini Mohamed Anivolla and Bammo Agonla from Etran Finatawa. Keeping their culture and traditions alive is the focus of many African musicians, and this fascinating event – including a specially-commissioned film, digital exhibition and live performance – promises to be an immersive, thought-provoking experience.

The Endless Journey

With a finale to bring celebrations to an unforgettable climax – plus a series of free concerts and workshops taking place across Manchester's museums and galleries, the *We Face Forward* season is not to be missed.

For further details on all these events and the latest concert announcements, please visit www.wefaceforward.org

We Face Forward: Anansi Stories
The Manchester Museum, 2 June – 16 September 2012

A popular character in West African and Caribbean folklore, Anansi the Spider is a trickster who started life as a man, but due to his mischievous ways was turned into a spider by his father, the Great Sky God. Because of his small size, Anansi uses his intelligence to survive and stories of his adventures have a lot to teach us all.

Using its natural history and ethnographic collections, the Manchester Museum has worked with the African Caribbean Carers Group and artist Alan Birch, to develop a re-interpretation of the Anansi Spider stories. The project began with a screening of an animation of *A Story a Story*, a book written and illustrated by Gail E. Haley that retells the African tale of how, when there were no stories in the world for children to hear, the trickster Anansi obtained them from the Sky God. Objects from Ghana that appear in the story – a calabash, a prayer stool and a jaguar disguised as a leopard with terrible teeth – were chosen from the collection to both introduce the Museum and also act as prompts for storytelling.

We have also worked with the Royal Exchange Theatre and the Men's Room community group to interpret and perform the Anansi story. Writer Louise Wallwein has also shaped the group's stories into a performance that will be showcased at the Big Saturday event with a number of performances throughout the day.

Another outcome of the project has been the arrival of the first West African spider into the Museum's arthropod collection. The Earth Spider from West Cameroon has been donated by tarantula expert Richard Gallon and is on display in the Museum.

The centrepiece of the display in our foyer will be the *Untitled (Cocoa Pod)* by Ghanaian artist Paa Joe. Such coffins are commissioned by the community of the recently deceased person. Choosing the most appropriate shape to commemorate the deceased, a maquette is made while the community raises funds. It takes about three months to make the full-sized coffin.

Paa Joe was born in 1945 in the Akwapim hills north-east of Accra, Ghana, and his work is held in museum collections around the world including the British Museum. Each work is carefully constructed to reflect the ambition or profession of the deceased. They are not dead things but are instead a manifestation of and indeed an affirmation of life. The works are wholly African and are a contemporary embodiment of traditional tribal funerary rituals and art. They make a fitting connectionbetween West African tradition and the better-known funerary practices of the ancient Egyptians (also Africans) whose objects are so important to our collection.

Anansi Stories Workshop at the Manchester Museum
Photograph by Paul Cliff
Image courtesy Manchester Museum

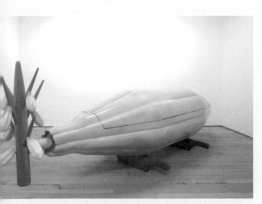

Paa Joe
Untitled (Cocoa Pod) 2011
Image courtesy Jack Bell Gallery, London

Moving into Space: Football and Art in West Africa
National Football Musuem, 6 July – 31 December 2012
Martin Barlow

To mark the opening of the National Football Museum in Manchester, working with the West African energy of *We Face Forward*, and with Senegal playing Team GB at Old Trafford for their opening Olympic match, *Moving into Space* adds a further dimension to Manchester's West African summer.

While football has become a worldwide phenomenon, in West Africa it has worked its way into the very fabric of society, from the street games of children to the large amounts spent on national teams by governments seeking electoral advantage. In *Moving Into Space: Football and Art in West Africa*, 11 contemporary artists use football to explore wider social issues including those of globalisation and trade, gender relationships, corruption and violence.

Its form evoking both a football and a time bomb waiting to explode, Romuald Hazoumè's *Exit Ball* suggests popular frustration at the way governments use events such as the World Cup to distract attention from issues such as the lethal trafficking in illicit fuel (in the plastic jerry cans from which the piece is made) which undermines the country's economy. Abdoulaye Konaté claims that *Homage to the Referees* is no more than a tribute to those abused men without whom a game cannot take place. Yet a context of violent conflict and evangelical Christianity recalls the biblical passage 'Blessed are the peacemakers: for they shall be called the children of God'. Pascale Marthine Tayou's installation *Golden Nuggets* refers to the corrupting influence, in all senses, of the huge amounts of money washing around football, in contrast with the realities of the lives of the majority of fans and local team players in Africa. Gérard Quenum from Benin uses his trademark discarded dolls from overseas aid parcels to make witty 'portraits' of individuals observed in his local environment, and which then serve as a lens through which we see Africa itself.

Nigerian photographers Andrew Esiebo and Uche-James Iroha both address the gender stereotypes prevalent in West African society and in football. The women they portray challenge the viewer to deny them the place earned by them in a society in which football is trumpeted as the game that knows no boundaries of age, gender or status, but in which women remain disadvantaged. Meanwhile Uchay Joel Chima uses video to suggest the hold that the dream of playing in Europe like their footballing heroes has on the minds of millions of young Nigerian boys imagining an escape from the harsh conditions of their lives.

Four Ghanaian artists complete the selection. Owusu-Ankomah's paintings incorporate both symbols and footballers in action. His desire to integrate humankind's commonality in a universally acceptable artistic language has obvious parallels with the now universal language which football has become. Atta Kwami's abstract paintings, titled after noted West African footballers, reflect on art itself and the way colour and form alone may express the associations conjured up by mention of a player's name. Godfried Donkor's

George Afedzi Hughes
Parallel 2009/11

Acrylic, oil and enamel on canvas
Image courtesy the artist and
National Football Museum

collages of footballing 'saints' are a meditation on the commercialization of human beings, from its most extreme form in slavery to subtler variations of the 'human goods' trade in the sports and entertainment industries. Finally, George Afedzi Hughes's paintings address power relations and the use of violence to solve geo-political conflicts, together with the way globalised communications bring such violence to us at the touch of a button.

While few of the artists venture to state that football or art can affect whole societies rather than changing the lives of individuals who happen to make their mark in the game, they imply in these works that football will remain a powerful instrument for conveying messages about society.

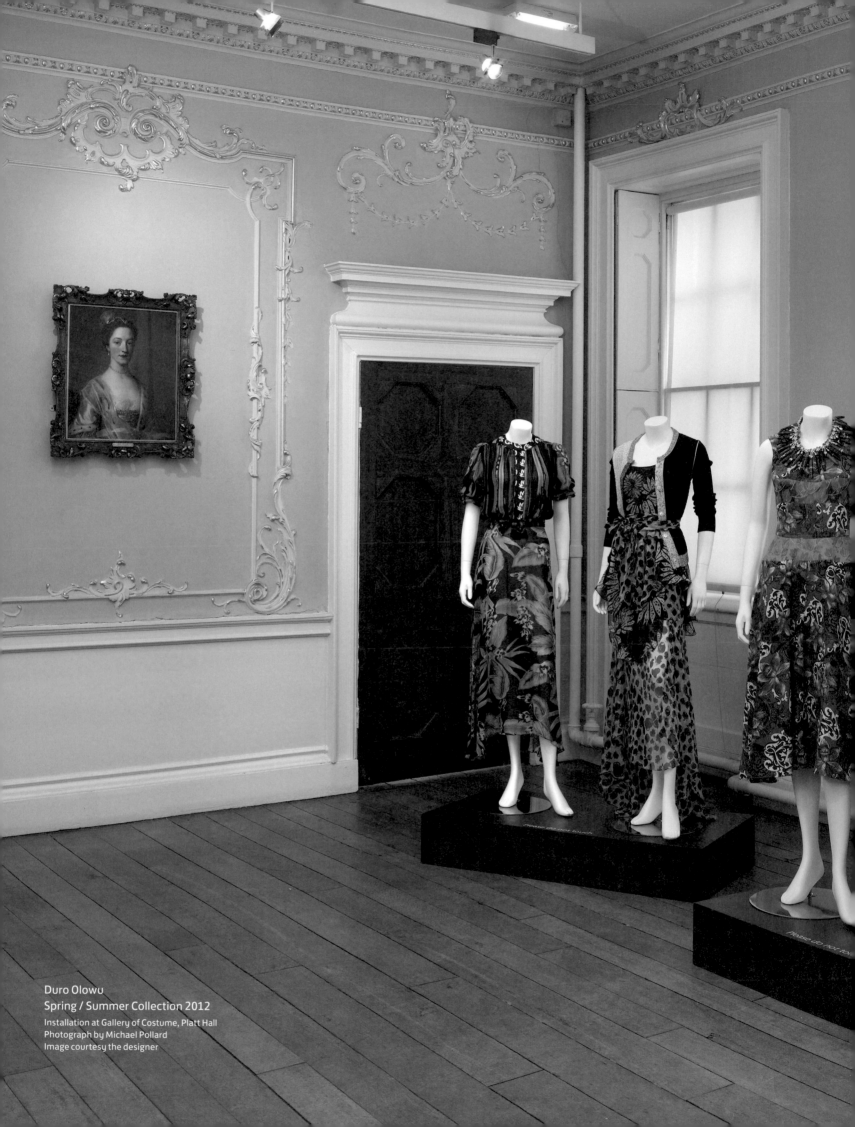

Duro Olowu
Spring / Summer Collection 2012
Installation at Gallery of Costume, Platt Hall
Photograph by Michael Pollard
Image courtesy the designer

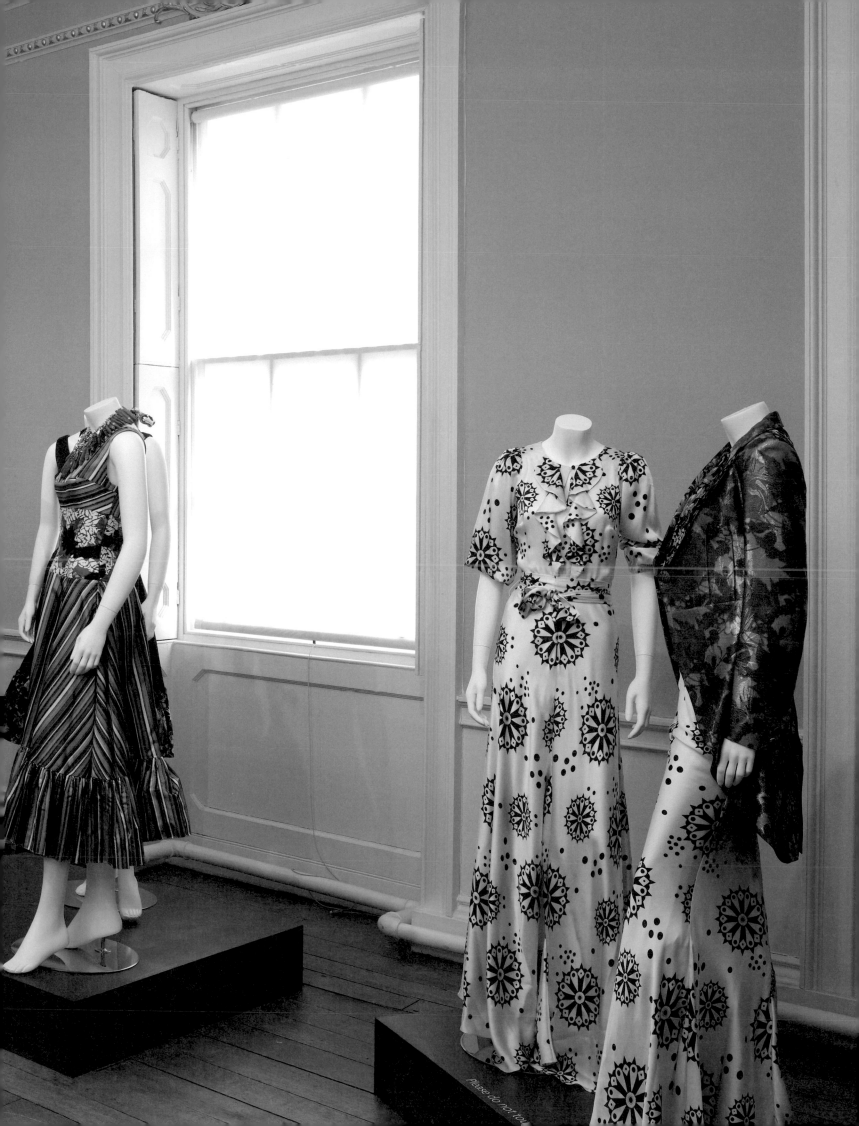

List of Works:
Manchester Art Gallery

Hélène Amouzou
Selection from *Self Portraits Series
(Série Auto-portraits)* 2008 – 2009
5 digital prints
Courtesy the artist

El Anatsui
*In the World But Don't Know
the World* 2009
Aluminium and copper wire
Courtesy the artist and October Gallery,
London

Mohamed Camara
*The Curtains of Mohamed
(Les Rideaux de Mohamed)*
2004 and 2012
Video
Courtesy the artist and Galerie Pierre Brullé,
Paris

Cheick Diallo
Sansa and *Wotro* 2012
Steel, woven nylon and cord chairs
Collection Manchester City Galleries
With thanks to Perimeter Art and Design,
Paris

Aida Duplessi
Sanaba Rouge 2012
Woven vetiver root rug
Purchased from the artist

Aboubakar Fofana
Obsessions 2012
Mud dye on linen
Commissioned by Manchester Art Gallery
Courtesy the artist

Meschac Gaba
Ensemble 2012
Flag
Commissioned by Manchester Art Gallery
and Whitworth Art Gallery, The University
of Manchester
Courtesy the artist

Romuald Hazoumè
Sénégauloise 2009
Wax Bandana 2009
Mixed media
Courtesy the artist, Robert Devereux
Collection and Private Collection

Abdoulaye Armin Kane
*The Event (Yaatal Kaddou or
L'Evènement)* 2008
Animation
Courtesy the artist

Abdoulaye Konaté
*Power and Religion (Pouvoir et
Religion)* 2011
Cotton and vegetable dye
Commissioned by Iniva (Institute of
International Visual Arts), London
Courtesy the artist

Emeka Ogboh
Lagos Soundscape (LOS-MAN)
2012
Amplified sound
Commissioned by Manchester Art Gallery
and Whitworth Art Gallery, The University
of Manchester
Courtesy the artist

Abraham Oghobase
Untitled 2012
4 digital prints on aluminium
Courtesy the artist

Amarachi Okafor
The Shape of Hanging Skin 2009
Synthetic leather off-cuts
Courtesy the artist

Charles Okereke
Selection from *The Canal People*
series 2009–2010:
*Our Reflections, Ahoy, Red Peeping
Mermaid, The Vein Travellers,
Fuelled Tank, Once in a Blue World*
7 Duratrans encased in perspex
Courtesy the artist

Nnenna Okore
*When the Heavens Meet
the Earth* 2011
Burlap, acrylic, dye
Courtesy the artist and Robert Devereux
Collection

George Osodi
Oil Rich Niger Delta 2003–2007
Digital slideshow
Courtesy the artist and Z Photographic Ltd

Nyaba Léon Ouedraogo
*The Hell of Copper (L'Enfer du
Cuivre)* 2008
7 digital prints
Courtesy the artist

Piniang
*Powercut in the Suburbs (Delestage
en Banlieue)* 2011
*Flood in the Suburbs 1 (Inondation
en Banlieue 1)* 2011
*Flood in the Suburbs 2 (Inondation
en Banlieue 2)* 2011
Newspaper collage, acrylic and pigment
on canvas
Ndakaru 2012
Animation
Courtesy the artist

Nyani Quarmyne
Selection from *We Were Once
Three Miles from the Sea* series
2010 – 2011:
*Though you Sweep the Hut in the
Sand, the Sand will not Disappear*
*We Were Once Three Miles
from the Sea*
This is my Home
A Beach in my Living Room
*Homeowner and Disappearing
Home*
Collins in a Window
Paulina's House
7 digital prints
Courtesy the artist

Pascale Martine Tayou
Poupées Pascale 2010 – 2012
16 works, crystal, mixed media
Courtesy the artist and Galleria Continua,
San Gimignano / Beijing / Le Moulin and
Cathy Wills Collection, London

*Les Sauveteurs Gnang Gnang
(Femelle et Mâle)* 2011
Crystal, mixed media, wood, cowrie, tissue
Courtesy the artist and Galleria Continua,
San Gimignano / Beijing / Le Moulin

Barthélémy Toguo
Redemption 2012
Mixed media
Commissioned by Manchester Art Gallery
Courtesy the artist, Bandjoun Station,
Cameroon and Galerie Lelong, Paris

Séraphin Zounyekpe
Street Vendors (Les Vendeuses)
2011
Digital slideshow

Under the Bridge (Sous le Pont) 2007
The Other Side (L'Autre Côté) 2011
The Crossing (La Traversée) 2009
At the Petrol Station (A La Pompe)
2010
Videos
Courtesy the artist and Stephan Köhler/
jointadventures.org

List of Works:
Whitworth Art Gallery

Georges Adéagbo
The Becoming of the Human Being, Talking about the Destiny of the Human Being, and Showing the Destiny of the Human Being. The King of England and the Queen of England. (Le devenir de l'être humain, parlant du destin de l'être humain, et faisant voir le destin de l'être humain. Le roi d'Angleterre et la reine d'Angleterre)
2000 and 2012
Mixed media
Courtesy the artist and Stephan Köhler/jointadventures.org

Lucy Azubuike
Selection from *Wear & Tear* series:
20 2011
21 2011
22 2011
23 2011
24 2011
Collaged paper and gouache on canvas
Courtesy the artist

Em'Kal Eyongakpa
Njanga Wata 2011
Video installation
Courtesy the artist

Meschac Gaba
Ensemble 2012
Flag
Commissioned by Manchester Art Gallery and Whitworth Art Gallery, The University of Manchester
Courtesy the artist

François-Xavier Gbré
Selection from *Tracks* series:
Hippodrome I, Bamako 2009
Swimming Pool II, Bamako 2009
Swimming Pool VII, Bamako 2009
Elizabeth Theatre I, Tiberias 2009
Elizabeth Hotel I, Tiberias 2009
La Duchère I, Lyon 2010
6 giclée prints on paper
Courtesy the artist

Romuald Hazoumè
ARTicle 14, Débrouille-toi, toi-même! 2005
Multi-media installation

La Roulette Béninoise 2005
Video

Kpayo Oil 2004

Twin Airbags 2004

Public Transport (Transport en Commun) 2004
Print on aluminium
Courtesy the artist and October Gallery, London

Nii Obodai
From the Edge to the Core 2009
1966
26 digital prints

Galamse
7 digital prints

The Passing
10 digital prints

Portraits
6 digital prints
Courtesy the artist and Institut Français

Emeka Ogboh
Lagos Soundscape (LOS – MAN) 2012
Amplified sound
Commissioned by Manchester Art Gallery and Whitworth Art Gallery, The University of Manchester
Courtesy the artist

Amadou Sanogo
The Last Crowd (Les derniers bain de foule) 2011
Perennial Arsehole's Gaze (Le regard des cons permanents) 2011
Journalists' World (Le monde journalistique) 2011
The Disabled Gaze (Le regard handicappé) 2011
The Jury (Le juré) 2011
Acrylic on fabric
Courtesy the artist

Pascale Marthine Tayou
The World Falls Apart (Le monde s'effondre) 2012
Mixed media installation
Commissioned by Whitworth Art Gallery, The University of Manchester
Courtesy the artist and Galleria Continua, San Gimignano / Beijing / Le Moulin

Barthélémy Toguo
Purification 2012
Watercolour on paper
Commissioned by Whitworth Art Gallery, The University of Manchester
Courtesy the artist, Bandjoun Station, Cameroon and Galerie Lelong, Paris

Victoria Udondian
Aso Ikele (1948) 2012
Used clothes from Manchester, UK and printed fabric and burlap from Nigeria
Commissioned by Whitworth Art Gallery, The University of Manchester
Courtesy the artist
With thanks to I&G Cohen Ltd and Islington Mill, Salford

Raw Material Company, Dakar, Senegal

Mansour Ciss Kanakassy
The Afro currency: Homage to pan-africanism (L'Afro notre monnaie: Hommage au panafricanisme) 2010
Print on aluminium
Courtesy the artist and Raw Material Company, Dakar, Senegal

Otobong Nkanga
Taste of Stone: Demarcate 2010
Taste of Stone: Lying with a Weapon I 2010
Taste of Stone: Lying with a Weapon II 2010
Inkjet prints on stone and wood
Courtesy the artist and Raw Material Company, Dakar, Senegal

List of Works:
Gallery of Costume, Platt Hall

Meschac Gaba
Ensemble 2012
Flag
Commissioned by Manchester Art Gallery and Whitworth Art Gallery, The University of Manchester
Courtesy the artist

Hamidou Maiga
Untitled 1973 (five photographs)
5 gelatin silver prints from original negatives
Collection Manchester City Galleries
Anonymous gift, courtesy Jack Bell Gallery, London

Soungalo Malé
Untitled, Mali 1959 – 1960
20 digital prints from original negatives
Courtesy the artist's estate and the Musée National du Mali

Duro Olowu
Spring / Summer Collection 2012
Bamako Chic, Autumn / Winter 2007
Multi print silk lame and cotton dress
Courtesy the designer

Abderramane Sakaly
Untitled, Mali 1958
16 digital prints from original negatives
Courtesy the artist's estate and the Musée National du Mali

Malick Sidibé
Untitled, Mali 1963 – 1976
14 digital prints from original negatives
Courtesy the artist's estate and the Musée National du Mali

Foreground:
Charles Okereke
Selection from *The Canal People*
series 2009 – 2010

Background:
Nyaba Léon Ouedraogo
All images *The Hell of Copper*
(L'Enfer du Cuivre) 2008
Installation at Manchester Art Gallery
Photograph by Michael Pollard
Images courtesy the artists

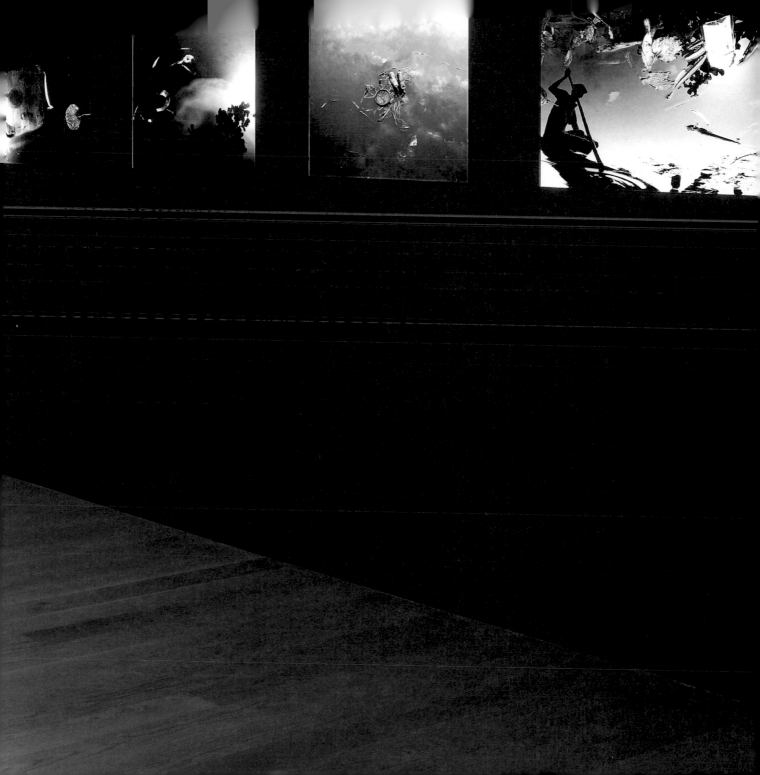

Above:
François-Xavier Gbré
Selection from *Tracks* series

Right:
Lucy Azubuike
Selection from *Wear & Tear* series
2011

Installation at Whitworth Art Gallery
Photograph by Michael Pollard
Images courtesy the artists

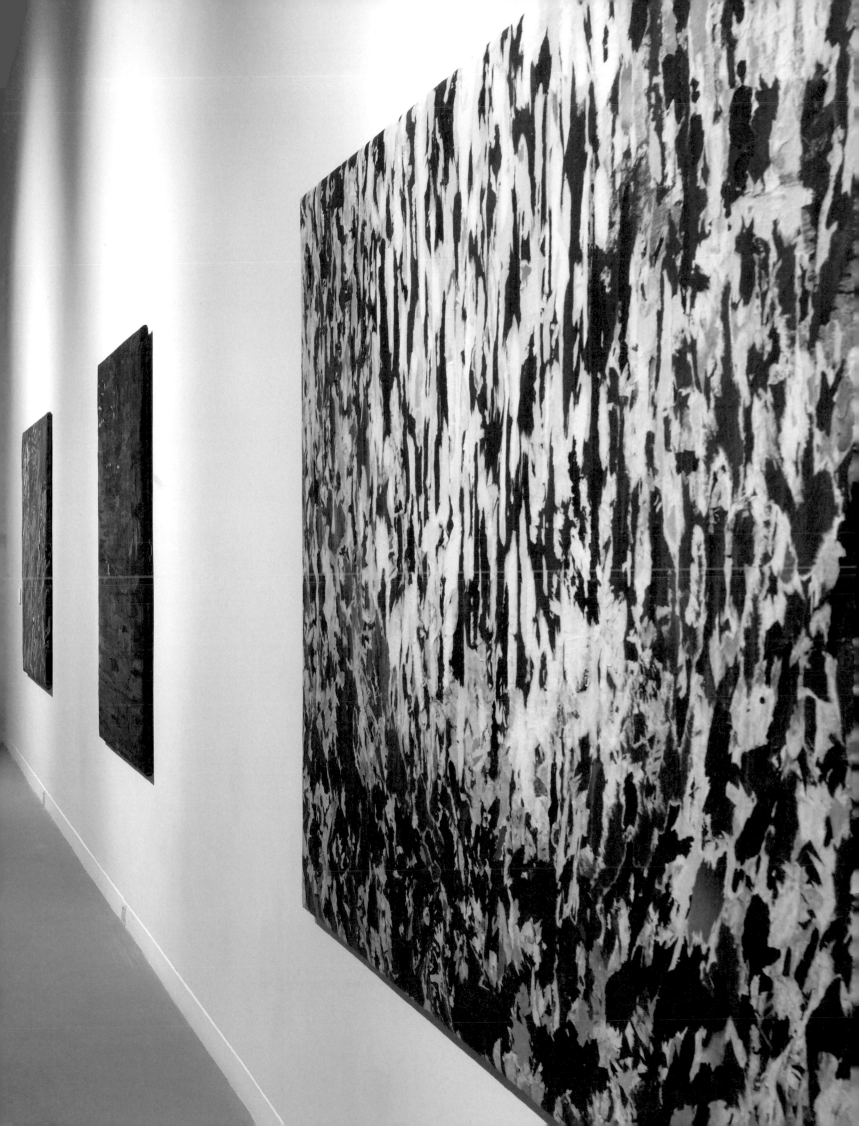

Colophon

Published by Manchester City Galleries and Whitworth Art Gallery
for the exhibition

We Face Forward: Art From West Africa Today
2 June – 16 September 2012

Artistic Director: Maria Balshaw
Curators: Bryony Bond, Mary Griffiths, Natasha Howes
Catalogue Co-ordinator and Artistic Liaison: Emilie Janvrin
Advisory Panel: Martin Barlow, Christine Eyene, Lubaina Himid,
Koyo Kouoh, Alan Rice
Designed by Axis Graphic Design
Set in FS Jack and Fakt Pro
Printed on Arctic Volume FSC accredited stock by DeckersSnoeck,
Antwerp, Belgium

Manchester Art Gallery
Mosley Street
Manchester
M2 3JL
www.manchestergalleries.org

Whitworth Art Gallery
The University of Manchester
Oxford Road
Manchester
M15 6ER
www.whitworth.manchester.ac.uk

Gallery of Costume
Platt Hall
Rusholme
Manchester
M14 5LL
www.manchestergalleries.org

Supported by Manchester Art Gallery Trust, Zochonis Charitable Trust,
Arts Council: Grants for the Arts, Paul Hamlyn Foundation, Jonathan
Ruffer Curatorial Grants Programme, British Council, Institut Français,
Rencontres de Bamako: Biennale Africaine de la Photographie

ISBN number – 978-0-901673-81-7